CRAFT DESIGN AND TECHNOLOGY:
PAST, PRESENT AND FUTURE

K

To

D0492280

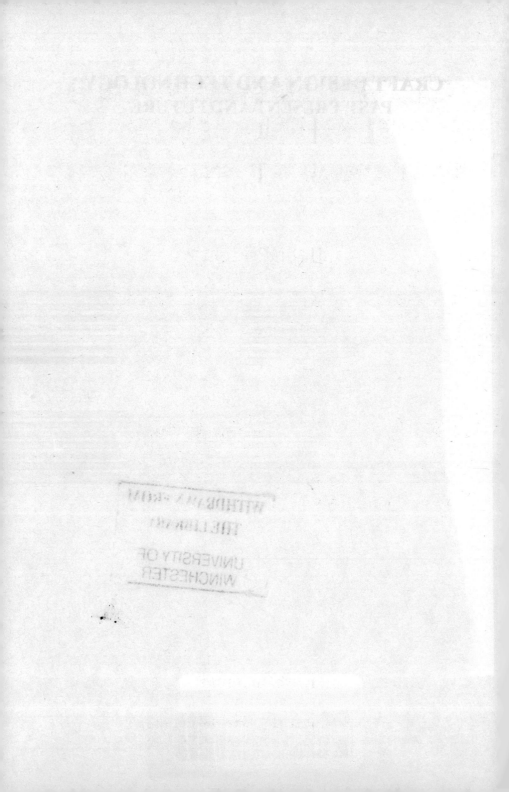

A Cornishman John Chenoweth by name and a joiner by trade. He taught carpentry as a labour of love before the advent of a woodwork master. He kept that school like a new pin. Of course he had to put up with a good deal from the scholars, but I never knew him to chastise the worst of his tormentors. He could chase them, rarely with success because of a dragging foot, but when he did corner his quarry, a forceful homily, a twinkle in the eyes, a pat on the shoulder and it was over. A devoted Methodist, on Sunday he too turned teacher. He must have been the original of the school caretaker who, seeing juvenile footprints embedded in the newly laid playground, declared that "he loved children in the abstract, but not in the concrete."[24.]

The promising Beethoven Street experiment came to an abrupt end when the Government Auditor disallowed the expenditure on the workshop building, tools and equipment.[25.] Sir Bernard Samuelson raised the closure in the House of Commons, but to no avail.[26.] Other means to finance manual instruction had to be found.

To return to Miss Clark and Miss Warren; they aroused so much interest in *sloyd* that they were in constant demand to give talks. Imbued with the Naas philosophy, both women believed girls should be taught manual instruction alongside boys. The girls working at Naas, observed Miss Warren, lost "none of their simplicity and sweetness, but tended to soften and humanise the boys." Early in 1885, Jane Warren left the London School Board to be an Inspectress of Schools for the Leicester School Board, but her advocacy of sloyd continued. Her articles in *The Practical Teacher* are the first on the Swedish system to be published in English.[27.]

Miss Warren wrote:

Is it not a disgrace to us as a nation that work, manual work is held in such low estimation, and forgive the digression when I add that I hope the time may come, and soon, when a factory girl shall have no power to say as one said to me the other day "Ah, Miss Warren you would not like to work *with your hands* in a factory?" Has not the child's education and former bringing up taught her that in point of fact we despise the 'handiwork' that is an honour and glory to our nation? Will my readers understand the superior relation I stood in with this girl when I was able to reply "No indeed, Nell, I too can use my hands, I have worked at a bench, and if ever the occasion should come up I shall stand side by side with the factory girls and learn of them even more; for God who gave us one head, gave us at the time two hands for labour, which clearly proves that the work you do in the factory is every whit as good as that which I do in schools.[28.]

She also recorded the surprise of foreign teachers at the Naas opening ceremony, to find two women representing England. They thought it impossible for English ladies to work with their hands.

Jane Warren argued that *sloyd* teaching gave children general dexterity that would equip them for a variety of jobs, whereas special trade training limited career opportunities. Moreover, as shown in Sweden, teaching was more effective when done by teachers rather than artisans. In the English apprenticeship system, comparatively few of the many technically competent tradesmen could actually teach their craft.

Evelyn Chapman

Another woman teacher, Evelyn Chapman, became the power behind *sloyd* in English schools, also following a visit to Naas in 1886. *The Journal of Education* published her paper on *sloyd* for the Teachers' Guild, and Lord Brabazon included it in his book *Some National and School Board Reforms.*[29] She gave lectures in Cambridge, Bedford, Sheffield, Leeds and Bradford, most of which subsequently became centres for *sloyd.*

Evelyn Chapman recognised that she had a marketable commodity that could be packaged for the middle class consumer. She invited Mathilda Nystrom, new Directress of the *Sloyd* Seminary for Training Teachers at Naas to run *Sloyd* courses with her in England, suited to English needs. To acquire premises, Miss Chapman wrote a letter to the *Journal of Education* offering free *sloyd* instruction to two teachers, in exchange for workshop accommodation.[30] The first offer they selected came from Bedford and after a successful course they held courses at Sydenham Ladies College and in Birmingham geared to middle class educational needs.[31] Soon the two women moved to larger permanent premises in London. *The Journal of Education* praised their initiative and advocated more experiments before sloyd was adopted on a larger scale. It commented that:

> ...it is the proper function of private schools to lead the way as they are freer to move.[32]

Jane Warren did not agree, fearing that if day and high schools benefited most from *sloyd,* the elementary sector would be left trailing. Those responsible for the poorer classes had to ensure that they did not loose out.

The flair and enthusiasm of both Jane Warren and Evelyn Chapman prompted a meeting to launch the formation of an association for *sloyd* in England.[33] The Earl of Meath, the first Lord Brabazon, agreed to be president of the proposed association and lent his drawing room for the meeting. Vice-presidents included Samuel Smith, MP, A.H.D. Acland, MP, Dr. Abbott, Dr. Gladstone, Miss Frances Mary Buss and Miss Emily Shirreff. Sir John Lubbock was treasurer and Abrahamsson and Salamon were invited to be honorary members.

Evelyn Chapman and Mathilda Nystrom's move to Camberwell, London proved highly successful. They founded the Home Sloyd Union as a commercial enterprise and published a journal *Sloyd or Handicraft.*[34] It included details of the women's activities. Courses for about fifty boys and girls were held regularly at their headquarters, initially mostly for pupils from private

schools. After legislation, the doors were opened to forty-five boys from a nearby elementary school and at the request of Stockwell College, courses were also arranged for pupils of the college's practising schools. There were regular exhibitions and both women continued to give lectures. But suddenly in 1891 they both emigrated to the United States to take up new appointments in Minnesota, leaving a gap in the English *sloyd* movement from which it never fully recovered.

Women publicists

In the year prior to the two women's departure others joined them. Increasing numbers of women began disseminating information on *sloyd*. By 1889 there were twenty travelling to Sweden to attend arduous courses and an undertaking that they would introduce *sloyd* into their own schools in England.

Many dashed into print. Adeline Pullor wrote long letters explaining the *sloyd* system to *The Fortnightly Review* and *The Saturday Review*.[35] Madeline Ward, after attending the 1886 Naas summer courses and later secretary of the English Sloyd Union, reported on *Sloyd at Naas* for the *Journal of Education,*[36] and an anonymous high schoolmistress wrote of her Naas experiences in *The Times,*[37] but the articles, though informative, had a frivolous tone, which enhanced the "jolly hockey sticks" image of *sloyd,* causing this reaction from one Yorkshireman;

> ...because some ladies had passed some very pleasant and agreeable weeks in Sweden, was no reason why English boys and girls should devote hours which might be otherwise employed, to the teaching of sloyd.[38]

Two women school board members who approached the problem of introducing manual instruction from different standpoints would not have been accused of frivolity.[39] Rosamund Davenport-Hill served on the School Board for London, Grace Johnstone on the west country Tavistock School Board. London stood in the forefront of the drive to introduce manual instruction, but Tavistock lagged behind, because:

> The bucolic mind, oppressed by the decline of profits in agricultural pursuits, thinks that popular education is quite dear enough already, and views with suspicion and jealousy the smallest addition to the rate for its maintenance. Therefore manual instruction, if it means building classrooms and paying master carpenters and designers, will never be introduced at all into the great bulk of our country schools.

Rosamand Davenport-Hill, nominated by the London School Board to serve on the Technical Education Sub-Committee, first learned of sloyd from Jane Warren when she submitted evidence to the Committee and herself visited Sweden in 1885. She approved of manual instruction being taught both as a general preparation for industrial occupations and as a means of alleviating the rigid teaching methods that predominated in board schools. Ideally she wished to see it as an extension of the kindergarten principle for all children.

Addressing the matter of cost she maintained that expenditure which contributed to "making good citizens rather than repressing bad ones' would be money well spent".

Grace Johnstone[40] echoed these ideas, but, in a typically middle class approach, considered manual instruction

> would tend to put boys and girls more on a par, to sweeten school life equally to both of them, and to render the two sexes equally handy and versatile for the whole of their future life in their respective spheres. Very few girls come into our houses as servants who cannot do something fairly respectable with their needles, and many a housemaid compels our admiration by the neatness of the seams and darns which she puts into the linen under her charge; but give the youth who cleans the boots and knives a bradawl or a pair of pincers, with which to put an extra screw in a bracket, or to turn a refractory gas-tap, he will almost certainly break the tool and not perform the job. We may at once trace the difference in these results to the early training received in the one case and to the want of it in the other.

Miss Johnstone also recognised the motivational value of the 'make it and take it home to mum' syndrome. It is easy to deride this but it did give craft teachers an advantage over their academic colleagues which should not be underestimated. In today's tough inner-city schools there is often less truancy from practical lessons and less disciplinary problems than in other classes.

Miss E.P. Hughes, Principal of the Cambridge Training College, and "a pupil and friend of that great educationist, Herr Salomon" became a committed convert to the educational value of sloyd. In an address to the College of Preceptors,[41] she rejected that sloyd be merely part of technical education, claiming that sloyd would be educationally invaluable even if there were no such thing as technical education. All children should learn sloyd, she said. "Children of all classes, girls as well as boys. They ought to learn it just because they are human beings". She stressed that if a poor country like Sweden could afford to introduce manual instruction, it must be within the means of a country as rich as England. Her appeal failed to persuade the Chairman, Dr. Fitch, the Chief Inspector of Schools. He could not see that the experience gained from sloyd was of an order different from that of the manual experience gained from cookery, needlework, drawing and writing.

Speaking at the annual meeting of the Froebel Society, Miss Hughes shared the platform with Miss Emily Shirreff, founder of the Froebel Society and Secretary of the Women's Educational Union, who also recognised the need to influence political power. A.J. Mundella, one of the politicians calling for the introduction of manual instruction, chaired the Froebel meeting. The combined advocacy of Mundella, Sir John Lubbock and Lord Brabazon helped to give sloyd standing and political bite. The subsequent publication of the *Hand and Eye,* a lively informative journal, as the joint organ of the Sloyd Association and the Froebel Society, considerably strengthened the links between them.[42]

Such was the interest in sloyd that the National Union of Teachers invited Otto Salomon to address its 1890 Easter Conference. Illness prevented his attending but his address was read, and still impressed by its breadth of understanding of English problems.[43] Salomon spoke of "manual training" but asked delegates to understand that he used the terminology in its Swedish sense, as meaning more than simply training the hand, which narrow interpretation did not excite him. The training of the hand should not feature only in the education of those destined to spend their lives in bodily toil but should equally be a part of the general education for children of all abilities. Salomon was at pains to point out that manual training, that is sloyd, could provide a sound general introduction for technical education. It could supply an "efficient preparation for the development of that mechanical skill, which is of so great importance in the various handicrafts". The address concluded with the hope that the audience would ensure that children received a "perfectly harmonious education of heart, and head, and hand".

Salomon gained converts everywhere including Thomas Godolphin Rooper HMI, who devoted his life to advancing and improving the quality of elementary education.[44] He also went to Naas, and personally financed a *sloyd* training course for teachers in Bradford, where he worked at the bench with his teacher colleagues.

English teachers who journeyed to Naas went to acquire practical skill and to absorb the philosophy of Otto Salomon. H.R. Reichel, Principal of University College, Bangor, became another distinguished speaker for Naas.

> ...it would bring the future teacher into direct contact with Herr Salomon...a man of great force and originality of character, and possesses unusual power of inspiring others with his own educational enthusiasm.[45]

A Nottingham teacher at a Naas summer school recalled in *The Schoolmaster*

> No one can listen to Herr Salomon's lectures without earnestly wishing to become better and nobler, both as a teacher and as an individual. His devotion to his work is so unlimited that even the most half-hearted must catch some of its infection and his personal hold over his students is so great that at his farewell address at the close of the course there was hardly a dry eye in the room.[46]

Dr. Woldermar Goetze, a leading proponent of manual work in Europe, directed the Leipsic Training school, which was influenced by Naas, recognised that elements of the Swedish system were inappropriate for German schools.[47] Dr. Goetze, like Salomon and many English teachers, opposed specifically industrial courses but he was critical of the Swedish concentration on wood. He argued that metal artefacts were important in German daily life and should be reflected in school manual instruction courses. Dr. Goetze hoped that the introduction of manual instruction would help balance the theoretical training characteristic of German elementary education. Some German teachers of

academic subjects reacted violently: manual work would lead to the "degradation" of the school!

British teachers also visited Dr. Goetze's establishment and, 'JBB' recorded her experiences in *The Journal of Education:*

> We were appalled to find we were the only ladies among about sixty men, who all gazed upon us as if we were some new and curious specimens of wild beast. They even took their cigars out of their mouths, that all features might express astonishment.[48]

A London elementary school teacher accompanied the three women who first went to Leipzig, to take courses in "Carpentry, Metalwork, Woodcarving and Cardboard work". Evidently the women's work compared favourably with that of the men's.

But the women sloydists and their male colleagues made little inroad into the opposition of Sir Philip Magnus and the technical education camp. The first Technical Instruction Act deemed the teaching of sloyd to be ineligible for the award of a grant. Outraged sloydists protested to the Department of Science and Art, where the Director explained that his information had suggested that sloyd was done "for the mere fun of the thing". However, "sloyd, as it had formerly been presented to him and Sloyd as he now found it, were two quite different things.[49] But his efforts to placate *sloyd* leaders were not enough to prevent a separation when a group comprising mainly ex- artisans founded the National Association of Manual Instruction Teachers with Sir Philip Magnus as its president. In 1897 the Sloyd Association merged with the Educational Handwork Association which was committed to the advancement of progressive education. The pioneering attempts of women sloydists to make manual work a genuine vehicle for education came to nought. By 1900 there were no more than a handful of women teaching manual instruction in elementary schools and none employed by the London School Board. Manual instruction became a subject taught by men to boys and this was the general pattern until the early 1970's.

The Sex Discrimination Act and Women CDT teachers

Most schools, though still not all have today complied with the Sex Discrimination Act. To throw open workshop doors is comparatively straightforward; to change the entrenched attitudes of a century old tradition is another matter. More than ten years after the 1975 Act, that tradition has merely been dented. There is some talk but virtually no positive action to recruit CDT teachers and the Women's Access Course at the Dudley College of Technology is virtually the only ray of hope. The author has been interested in the recruitment of women to CDT teaching since the mid-seventies. The Shoreditch College's Publicity and Recruitment Committee which he chaired, did succeed in increasing the number of women in initial teacher training for CDT. After the committee came to an untimely end in 1980, the recruitment of women to CDT courses fell, as did the number of men.

The Shoreditch Committee organised a conference 'Opportunities for Women in Teaching Craft, Design and Technology" in 1979 jointly with the DES, designed to stimulate recruitment of women across a broader section of the population. At the time there were less than 200 women in a teaching force of some 12,500 CDT teachers in the 5,000 or so secondary schools in England. Most of these women attended the conference and 104, over half the women then known to be teaching CDT, completed a questionnaire constructed by Margery Smalley, the Shoreditch College Conference Organiser, which affords us an insight into this minority group of women and the problems they encountered in their professional life.[50]

Over half the women were under the age of thirty and all but twenty of them were under forty. Most had taught CDT for less than five years and very few had trained with the intention of becoming a CDT teacher. Almost a quarter entered CDT teaching through one of the DES designated retraining courses. Slightly more came from an arts background, a number as graduates and four had a degree, or degree equivalent, in engineering. The women were critical of retraining courses and some women claimed to have been exploited during a period of staff shortage. Few of those who entered CDT teaching through one of these schemes thought that they would get beyond a Scale 1 post.

Most women found themselves teaching woodwork, metalwork and technical drawing in traditionally equipped workshops and wanted to see this changed, demanding a definition of CDT and a justification for its inclusion in the curriculum. In a man's world, women CDT teachers had to persevere against male jealousy, patronising attitudes or deliberate discouragement. Tables 1 and 2 may underestimate the degree of sexist attitudes among male teachers, since women were likely to be appointed only in schools in sympathy with Equal opportunities. The women experienced feelings of professional isolation, as can be seen in the tables below.

Two questions explored the attitudes of head teachers and heads of departments towards women. Tables 1 and 2 give the details.

Whilst a comparable group of male CDT teachers might well have echoed the women's responses to questions 1 and 2, questions, probing their knowledge and experience (Table 3) would have revealed a different situation. Whereas it was common change among men CDT teachers that their training concentrated too exclusively on workshop techniques and skills, the women obviously felt exposed without them:

Asked about promotion prospects, the women were not optimistic (Table 4). The women's qualifications and relative lack of experience might suggest that they should not have expected promotion, but those years of shortage gave male CDT teachers unprecedented promotion prospects. Latterly a few women can be found administering departments and faculties and in 1987 the ILEA appointed Sandy Morgan CDT inspector.

Table 1 HOW SUPPORTIVE IS YOUR HEAD TEACHER TOWARDS YOUR WORK?

Comments	Number of Responses
Excellent. Very Supportive. Gives full and complete support. Very enthusiastic, helpful, cooperative and sympathetic. Keen to get C.D.T. taught in all girls' schools.	45
Moderate, Average, Mediocre, occasionally supportive. Can be superficially supportive. Enthusiastic but does not understand the demands of the subject. Concerned about the subject in view of the cuts. Wants the Dept. to bridge the gap between Art and Craft and supports me in an effort to do this. Supportive when it is parents' evening and there's need for a display. The governors push the Head into being supportive. Full of good will but squanders money in the Drama Dept. If the media are involved, the Head can be very supportive.	25
Very little practical support given. Indifferent, disinterested, neither supportive nor critical. Has very little contact with the Dept. which is quite isolated in the school. Does not consider the Dept. of any importance. Not very forthcoming with funds. Gives little support to non-exam work. "I don't think he's noticed!"	16
Non-supportive to the Dept. as a whole. Rarely see the Head — he never comes near the Dept. A difficult man to see. "I once grabbed him by the arm and made him come and look at the work." Very temperamental. Head never seen unless he brings visitors. "Tells me he doesn't want to lose me — I'm a rare bird but in the same breath warns that I'm not going to get anywhere!"	17

Table 2 HOW SUPPORTIVE IS YOUR HEAD OF DEPARTMENT TOWARDS YOUR WORK?

Comments	Number of Responses
Excellent, very supportive, helpful, considerate. Very good. Enthusiastic. Is sympathetic towards the problems facing a female teacher in an all boys' school. The whole Dept. works as a unit and we support each other. Very helpful when asked for assistance. All the suggestions I have made he has considered and some changes have followed. Criticism is constructive. He's wonderful!	59
Reasonable, moderate, indifferent. Not exactly dynamic! I do exactly as I please. Traditional minded but allows me to develop my own ideas. Fairly supportive — as far as he is able. I often need to pressurize for information. He keeps at a safe distance. Working in a split site school one can't always get support when it's needed. H. of D. finds integration of Tech. Dept. with Creative Dept. into one Faculty very difficult.	20
No support whatsoever. Obstructive, pedantic, chauvinistic. Little contact, never discusses the work. Total lack of organisation, no guidance, no syllabus. Goes out of the way to find fault. Little aid or advice. Sees no value in the Design approach. Does not practice Craft, Design and Technology.	17
I am the Head of Dept. There's only me in the Dept. (Middle schools)	8

Table 3 **WHAT ARE SOME OF THE MAIN PROBLEMS YOU FACE AT THE MOMENT IN YOUR PROFESSIONAL LIFE?**

Comments	No. of times mentioned
Inadequate knowledge and experience Not knowing enough about C.D.T. There's a great need for a philosophy of the subject. What does it mean? it's necessary to have a clear structure and be aware of the standards of acceptance in C.D.T. A need to gain experience and confidence. "I haven't even got a C.S.E. in the subject I'm teaching." It's difficult to keep ahead of the pupils. A one year conversion course is inadequate. Not enough assistance is given to newly qualified teachers. There's a need for training in engineering, metallurgy, tool and machine maintenance and basic technical instruction. "I work in a trial and error fashion."	61
Departmental problems It's badly organised, traditional based, apathetic and dead! There is a lack of direction in the Dept. The approach to C.D.T. is too compartmentalised. Introducing Design into the Dept. creates problems. There are too few or no technicians for the Dept. A need for enhanced status for both the C.D.T. female teacher and the C.D.T. Dept. A lack of finance for equipment and its maintenance. Inadequate facilities. Staff shortage (C.D.T.). Being a female in an all male Dept. is difficult. "I'm held back, frustrated and hindered from doing the things I want to do.'	79
Problems related to school organisation Feeling isolated — split site problems. Not enough communication with other teachers. Having to do administration and school duties. The arrangement of the options. Classes are too large. Mixed ability teaching is difficult in open plan classrooms. Girls are not allowed to do C.D.T. Bright children are not encouraged to take C.D.T. and low ability children are	42

dumped in the Dept. "I have to move around the school so much, there's no control of stock." There's never enough time. Innovation too slow to proceed. Little communication between school and examination boards.	
Personal Problems Physical and mental tiredness. Discipline. Initially trained in another subject (Art) or age range (Primary) and uncertain about continuing as a C.D.T. teacher. No hope of promotion. Financially, inadequately rewarded. Difficulty in pursuing own development in subject (for a variety of reasons e.g. family, non-availability of courses). Lack of assistance from Adviser. Can't get on with men in Dept.	20

Table 4 HOW DO YOU RATE YOUR CHANCES OF PROMOTION?

Comments	Number of responses
Good. I'm hopeful	13
Reasonable. Average. Fair	5
I am ambitious and will make sure I get promotion	3
Not sure	6
I do the work but there's no allowance	4
Not in this school	17
Not in CDT (but in Gen. Studies, Pastoral Care, Home Econ.)	13
Promotion goes to the men	2
I need more training	6
Very little. Slim	14
Zero. Nil	22
Don't want promotion	1

The Equal Opportunities Commission enquiry 1985
In 1985 the EOC published its findings following

> a formal investigation under Section 67 of the Sex Discrimination Act 1975 into the recruitment of students for training, and to make any appropriate recommendations for the promotion of equality between men and women generally in relation to such matters.[51]

For the Commissioner's Report, 83 women CDT teachers completed another detailed questionnaire.[52] Despite the 6 year interval the findings of the two enquiries were virtually identical. Women still found themselves teaching CDT as much by default as by design.

Using data received from the 23 institutions which offered initial teacher training and/or retraining on CDT, the Commissioners made a number of recommendations. Accepting that many institutions were taking action to improve access for women to their CDT courses, the Report nevertheless stressed the need for "a more co- ordinated and cohesive approach...in order to improve what is essentially a national problem." But it does not determine who should be responsible for action. Increasing the supply of women CDT teachers is not an issue which generates much enthusiasm among male CDT teachers and managers.

Two researchers, Clive Seal and John Bloomfield, have found that teachers of science and craft subjects had the most sex stereotyped views, with the latter heading the list.[53] The structure of CDT teaching supports this. All members of HM CDT Inspectorate are male and so are all LEA subject advisers (until Sandy Morgan's appointment). Only a handful of the teacher trainers of the subject are women and men teaching CDT vastly outnumber women.

All except the most recent will have been taught craft in a boys' school or in a craft department that excluded girls in a mixed school.

Teacher training for many older CDT teachers will have been in a single sex institution or − if co-educational − in a department that had no women. It is of concern that, while provision for teaching girls CDT at secondary level − if not ideal − has changed substantially, teacher training institutions continue much as before. Most students on initial teacher training courses will not have much opportunity to work and study alongside women students in the same discipline. To compensate for this lack of balance, education and professional courses should pay special attention to the needs of girls − as the Equal Opportunities Commission spells out. Teaching strategies must be designed to make girls feel more at home in the workshops which often exude a male atmosphere, or students will take up teaching appointments prepared little better than their predecessors to make CDT a fruitful, rewarding activity for girls.

There are no official figures for the number of women currently teaching CDT. By now the 1979 figure ought to have doubled, but has not. Women CDT teachers in the ILEA and the south-east (where most women are employed) suggests that the wastage rate is high. A significant number of women

try workshop teaching, find it uncongenial and leave. Women who enter CDT through one of the retraining courses appear to be those most likely to withdraw though the EOC values the courses as a good way of quickly increasing the number of women. Available evidence indicates that retraining courses need to be longer; it is not their quality which is in question.

In December 1985 eleven women taking B.Sc (Hons) at Brunel University met to examine the difficulties they had experienced and confirmed the findings of both the Shoreditch and EOC enquiries. They had received their CDT training in haphazard and random ways, sometimes encountering active discouragement from their schools. Only a small minority had made an early decision to teach CDT. Whether at school, university or teaching practice, all had been the butt of sexist comment and abuse. Women found themselves "set up" by boys in school workshops. Evidently some fathers gave their sons tricky questions to ask their teachers that would damage the credibility of the teacher. The women students shrugged off these episodes but expected such behaviour to continue. Nevertheless they found teaching practice generally enjoyable and most classes accepted women CDT teachers without question.

Some of the students had fathers who encouraged their daughters to work with tools and materials, and brothers with whom they shared lego, meccano and construction kits. When women and CDT are bracketed together, invariably the association is at the design and craft end of the spectrum but, encouragingly, the Brunel course is strongly technological and the women students coped well. Most had been required to teach technology on teaching practice. But the women were not sure that they would be taking up teaching and neither of the two who graduated in 1985 entered teaching. If more women of this calibre cannot be encouraged to become CDT teachers the future looks bleak.

America and Scandinavia
Even in Scandinavia and the United States where the feminist movement has deeper roots, women teaching CDT have similar problems. A 1979 survey in the United States showed that women teaching Industrial Arts − the American equivalent of CDT − made up a mere one-third of one per cent of the total number of workshop teachers,[54] and no special provision was being made to increase the recruitment of women. In Denmark and Sweden the absence of women in the workshops is equally marked except for those teaching textile sloyd. As in the United States little change is expected. At the Esbjerg High School, one of the two main sloyd training institutes in Denmark, there was one woman student out of sixty four in 1983. In Sweden the old Naas Seminary moved from its original home near Gothenberg to Linkoping in the early sixties. Now part of Linkoping University, the Institute for Sloyd is no longer thronged with women students. Only four in 1983 were women, and they report similar experiences to those English women CDT students, and do not expect much change.

While there are women teaching the whole gamut of workshop activities ranging from automotives to electronics in America, virtually all were employed in teaching drafting and design, woods, general shop or crafts. Most of these women, and women considering taking up teaching Industrial Arts, see themselves as having been handicapped by having

> No previous experience − no hobbies while growing up, no classes in school, absolutely no exposure to the world of machines, tools and technology.

As in Britain, legislation could ensure mandatory equal course offering for boys and girls but could do little to make up for such deficiencies in the short term. American women believe that they perceive Industrial Arts differently from their male colleagues and wanted to see attitudes change so that less importance is attributed to the traditional project method and more to development of student self-confidence and goal setting. They want more emphasis on creativity and design in Industrial Arts as part of general education.

Progress since the Sex Discrimination Act of 1975

A survey conducted by HM Inspectorate in 1979 found that "...differentiation by sex in craft subjects occurred in practice if not by design in something over 65 per cent of the 365 schools" (in the sample)[55] They report, however, that traditional attitudes were observed to be changing. It seems likely that initially many headteachers who resisted the admission of girls to the workshops did not know that they were acting illegally, until headlines appeared as in the *Guardian* in 1978: "Car Maintenance Class Ban Spurs Girls to Report Head".[56] All schools have however now had time to make changes, so some schools are acting in defiance of the law and it is not being enforced. The Equal Opportunities Commission, perhaps because its action in the Whitfield v Croydon case was unsuccessful, prefers persuasion to prosecution. The EOC *News Release* of April 9, 1987 reports that the Commission has now begun an investigation into West Glamorgan schools not providing equal access to girls for CDT. Without the Commission's intervention, however, thousands of girls will continue to be denied genuine access to CDT for many years to come.

Sexist Attitudes in the Workshops

CDT is one of the most under-researched areas of the curriculum but there are many examples to support the hypothesis that sexist attitudes are widespread among CDT teachers.

The − probably few − blatant misogynists should be distinguished from those who are unfamiliar with problems of teaching girls rather than hostile towards them.

In a national survey conducted by the author and Margery Smalley in 450 secondary schools in England and Wales in 1976, most teachers in the sample recorded a neutral or favourable attitude towards girls taking CDT.[57] At that time comparatively few of the teachers responding had had direct experience

of teaching mixed classes. A significant number professed to have no strong feelings either way, then expressed their concern that opening up the workshops to girls effectively halved the time previously available for boys!

Regional surveys by the author and Margery Smalley in the late seventies did not support a general view of a north/south divide on the question of girls and CDT. The responses to a questionnaire by almost 90 per cent of heads of CDT departments in Durham in June 1978, were typical.[58] Two items related to girls:

Question
If you teach in a mixed school what provision is made for girls to take Design Technology subjects?

In 15 schools no provision made at all.
In 32 schools the amount of time allowed for girls to participate varied considerably. Generally, facilities were available equally to boys and girls in the first 2 years in the secondary school.

Question
What are your attitudes towards girls taking Design Technology?
(37) In principle, in favour of girls studying Design Technology
"Taking girls can be fun"
"The more the merrier"
"O.K. if it's for the right reasons"
Concern frequently expressed that time-tabling is a problem.
There is just not sufficient time to do justice to the subject if girls allowed to study Design Technology.

(7) Not in favour. Objections in particular to girls starting the subject in the 4th year having had no previous experience. Regrets expressed that girls take up time which boys could utilise more profitably. If girls are to be taught then single sex groups are preferable. The time that one spends on the subject is cut by half.

(3) Undecided, indifferent, no strong feelings either way.

In June 1978, *The Times Educational Supplement* published a photograph of a woman metalwork teacher demonstrating a turning operation on the front page.[59] It related to an article by Shirley Williams, about gender equality. Two weeks later this letter appeared in the correspondence columns.

Not on her metal
Sir,
In your front page picture of Mrs Elain Wilson "teaching" metalwork (June 30) the boy is giving her an appropriately sympathetic look. She is not wearing goggles, she has no restraint on her long hair or her loose sloppy sleeves on her dress.

Wouldn't it be interesting if a piece of hot metal swarf went down the low neck of her dress?

If that is the best women can do, then keep them out of our workshops before many dangerous practices are taught and cause serious injury in schools and factories.[60]

Presumably the TES published the letter to promote a furore in the correspondence columns in following weeks, but if so it failed, and the sexist opposition to women teaching CDT by the correspondent went unchallenged.

One of the more worrying factors about research into the incidence of sexism in the workshops is that probably most CDT teachers are unfamiliar with it. Sara Delamont has recorded other examples of sexism, often of a wholly unconscious nature:

Melin Court (4.9.78)
In the woodwork room the new pupils are being allocated places at the benches, in alphabetical order, with the boys first. When Mr. Beech found he had twenty-three in the group, it was the girls who were left without bench places − about three girls left to work where someone was absent (i.e. changing seats every week starting each lesson trying to find a space).

Waverly (20.9.78)
Technical Drawing − Mr. Plumb
There are more pupils than bench spaces so Parween and a boy are on the side bench, and three girls are down the front.
Waverly (8.9.79)
After break to technical drawing with Mr. Quill.
He lines them up at back and sides of the room, gives them seats in alphabetical order. Boys first − leaving spaces for absentees. There are twenty-eight in the class so five girls get left off proper desks and given slots on the side benches. They then are told they can sit in absentees' seats.[61]

She observes that "Anything more calculated to make girls feel uneasy in wood and metal work or technical drawing than to fail to give them a permanent seat is hard to imagine!" Gay Randall refers to the unconscious nature of much sexism:

Many teachers who are unhappy at the suggestion that they may contribute to the sex-stereotyping of their pupils like to feel that they treat all their pupils as individuals regardless of sex. When pupils enter the classroom, laboratory or workshop they have already been subjected to years of socialisation into their sex roles, and all that is needed to reinforce that is just to accept it...The teacher who is aware of stereotyping that could be reinforced in his or her classroom, however, is in a position to intervene by changing his or her responses so that potentially harmful stereotypes and patterns of interaction are not reinforced.[62]

It is probable that many CDT teachers who sincerely believe that they are giving girls parity with boys may unwittingly contribute to sex-stereo-typing.

Dale Spender warns of the consequences:

> When girls do not receive the same attention as their male peers, when they are not presented with materials that encompass them, their lack of confidence is confirmed. There is a constant implicit message that they "do not count!" This can in turn reinforce a negative self image, reduce their level of aspiration and lead to even further withdrawal. Such a cycle needs to be broken.[63]

This all adds up according to Carol Dweck of the University of Illinois, who describes the "learned helplessness" by which girls underestimate their ability and have less confidence to tackle new tasks and concepts.

> Learned helplessness was caused by the different patterns of praise and criticism given to the two sexes from teachers. Girls and boys received the same amount of criticism, but girls were nearly always criticised on intellectual grounds, while boys were criticised half the time on non-intellectual aspects such as effort or presentation.

> The difference in treatment led girls to attribute their failure to lack of ability whereas boys blamed failure on lack of effort or the nature of their task. This encouraged boys to think that they can do better with more effort.[64]

These illustrations of the treatment of women and girls, in CDT or in a more general educational context, as second class citizens is disturbing. Whether they are part of a deep-seated malaise or the result of the changes caused by opening up workshops to girls for the first time remains to be seen.

The Attitudes of Girls

A conference held at Shoreditch College in 1978 on 'Education and Industry' enables us to investigate the attitudes of girls to CDT. It was designed to widen the career and educational horizons of 13 and 14 year old girls before they made their CSE and GCE subject choices. Organised by the author and Margery Smalley, the conference was attended by over 400 girls from 32 schools in Buckinghamshire, Berkshire, Hertfordshire, Surrey, Northants, Sussex, GLC boroughs and ILEA. CDT had not seen anything like it before. Margaret Jackson MP, then Secretary of State for Education at the DES and herself a metallurgist, urged the girls to consider careers in engineering and technology and described the under-representation of women in these areas.

The girls attending the conference may not have been representative: more likely, they had been taught by enthusiastic teachers. The satisfaction the girls derived from their first workshop experiences is clear from their responses to a

questionnaire that 193 of them completed. (Table 6) and a year later this had not diminished as 134 girls, now in third year, testify. (Table 7).[65]

Table 6
IN RESPONSE TO THE QUESTION: 'WHAT DO YOU MOST LIKE ABOUT CRAFT?' 193 SECOND YEAR GIRLS GAVE THE FOLLOWING REPLIES.

67	Experiencing feelings of satisfaction and achievement derived from making things.
44	Craft is interesting and enjoyable. It's different and not boring. It can be fun.
16	Doing practical work and using one's hands.
15	Drawing (This could refer to Art and/or TD − unspecified)
14	Designing things.
14	Seeing how things are made using different materials and different tools.
7	Woodwork.
3	Jewellery.
3	In doing this subject it shows that girls are just as good as boys.
2	Occupational possibilities.
2	Metalwork.
19	No technical subjects studied so far.

Table 7
134, THIRD YEAR GIRLS IN REPLY TO THE SAME QUESTION, 'WHAT DO YOU MOST LIKE ABOUT CRAFT? RESPONDED A YEAR LATER.

37	Satisfaction, seeing the end product and making things.
28	Craft is interesting and enjoyable. It's different.
18	Doing practical work and using one's hands.
18	One can be creative, use self expression and imagination and be independent. It's possible to work at one's own pace.
12	Variety and choice of jobs that are available. Having access to equipment and materials.
6	Designing.
3	Metalwork.
3	Being equal to boys. It's daring for a woman.

The girls were also asked to record what they least liked about CDT. (Tables 8 and 9). Significantly, their only complaint was about the teaching strategies that took them away from making things. Most girls in 1978 would have been taught in workshops organised on the circus system, discussed in the next section.

Table 8
'WHAT DO YOU LEAST ENJOY ABOUT CRAFT LESSONS AT SCHOOL?'
INSPIRED THE FOLLOWING RESPONSES FROM 193 SECOND YEAR
GIRLS.

34	Too much theory and writing. Not enough practical work.
30	Designing and planning and drawing.
20	The teachers. The way they repeat things and keep the class waiting.
19	I like everything.
19	Not having enough time.
7	Limited choice of things to make.
6	Doing something I can't do well.
6	Accident.
6	When something doesn't turn out properly.
6	Clearing up.

Table 9
REPLIES OF 134 THIRD YEAR GIRLS, TO THE SAME QUESTION
'WHAT DO YOU LEAST ENJOY ABOUT CRAFT LESSONS AT SCHOOL':

25	No comments in response to this item.
18	The theory and the writing. Discussion.
16	I like everything.
13	Designing, planning and drawing.
10	Aspects of Metalwork and Woodwork lessons. e.g. filing and sanding.
10	The teachers. Having to wait for teachers to give help.
8	Boring.
6	Using machines. The noise of machines.
5	Limited choice of things to make.
4	When things go wrong and when it's difficult.
4	The end of the lesson and having to stop.
4	Clearing up.
2	Men teachers are prejediced towards girls doing this subject.

Whatever its alleged deficiencies, the girls found it a broadening and enjoyable educational experience and the Equal Opportunities Commission elicited similar enthusiasm from the 500 girls of the same age who attended a comparable conference in Manchester a year later. Few older girls had the opportunity to take craft in their first two or three years, so began examination courses from scratch in the fourth year. Over the years the author has talked to many of the small number of girls who pursued the subject to 'A' level, exploring informally their attitudes and the difficulties they experienced. The following is an extract from one conversation in 1978 with Anne, who was studying Design and Technology at an inner-city comprehensive school in south-east London.

I: 'Do you think it is unnatural for girls to do Design and Technology?
A: No I don't!
I: Are there any more girls in your group?
A: No – there were two – but they backed out.
I: What quality do you have above everything else.
A: Determination
I: What has been the attitude of the boys to you?
A: Boys put you down – until I passed the exam and then they didn't. I then felt sorry for them.
I: So you feel accepted now?
A: Yes – except when I join up with sixth formers at a nearby grammar school – they look down on comprehensive pupils.
I: When options were made in the third year, why did you take Design and Technology?
A: Because I liked it. It's very satisfying.
I: Do you feel a bit of a missionary?
A: No I don't – suppose I must be looked on as a good example though.
I: Do you feel the work is a bit tough, physically I mean?
A: No.
I: How do you get on with the engineering parts of the course?
A: I don't like engineering very much, probably because most of my experience has been in wood and art type subjects.
I: How about technical drawing; how do you get on with that?
A: I prefer the geometrical aspects. I find it difficult to visualise engineering projects unless there are examples available.
I: How do you get on with the craft staff?
A: They're great, really great! they give me a lot of support.
I: Is homework a problem?
A: Design, no problem; theory ugh!
I: How do you see yourself?
A: A practical sort of girl.
I: Did you ever consider the status of Design and Technology?
A: No.
I: I hear that you might take up Design Technology teaching.

A: I did — I might — that's another reason why I wanted to do Design and Technology 'O' level when I made my option choice. Now it's opened up a few more opportunities.

I: Would you be worried if you were the only girl on the course?

A: No, I'm used to that now

I: Is there anything you don't like about Design and Technology?

A: I don't like using machines — they make me nervous. Even after a good demonstration I still think that they can go wrong. I'm not too keen on jewellery either. I feel most happy when I'm working with a range of materials.

I: I suppose I had better ask you how your parents feel: have they encouraged you?

A: They thought it was a bit funny at first, but now they've got used to me. Think they're even a bit proud of me.

How typical was Anne of this first generation of girls taking CDT at 'A' level? Whilst Anne and her contemporaries may not necessarily have seen themselves as trail blazers, she did, nevertheless, show great determination to succeed in an area new to girls. They have slightly eased the passage of some who followed but, for the most part, girls embarking on a CDT course at Sixth form level in the 1980's still need the same qualities of persistence and perseverance. In 1982 — a bulge year in the sixth form — not much over 100 girls could be found pursuing Design and Technology at 'A' level in schools in England and Wales, and were often the only girl in class. If this situation is to change — and nine years after Anne's interview it has not — girls will have to feel less like pioneers and more like other sixth formers. The maleness of CDT must be broken through.

The CDT circus

The circus system where girls and boys circulate from one activity to the next at termly or half-termly intervals was the most common arrangement for accommodating the influx of girls into the workshops and boys into the home economics rooms. Head teachers and curriculum planners were delighted with a solution which involved no expense whatever! The CDT circus was rather like an educational musical chairs with the children rushing to their next destination as soon as the music stopped; that is until an ill-assorted group of erstwhile enthusiasts and anti- feminists started to take potshots at the pianist. Suddenly all the problems were blamed on the presence of girls: halving the time for each course had trivialized workshop activities, forced down standards of workmanship, jeopardised examination results and stifled technology in its infancy. Charges that these criticisms had sexist overtones were ignored rather than disputed. Yet this was a male view of the matter. The young girls at the Shoreditch conference enjoyed their craft lessons taught on this basis. Similarly, the Girls into Science and Technology (GIST) researchers found that

girls' parents were enthusiastic about these "taster" courses. From within the CDT circus critics seldom paid attention to the opinions that girls too needed practical activities and chose to ignore growing awareness outside of the CDT criteria that lack of competence in handling tools and materials handicapped girls' progress in other subjects. Thus the DES Discussion Document *Girls and Science* advocated that science teachers should work more closely with craft departments.[66] Both Lady Platt, Chairman of the EOC, herself an engineer, and Professor Daphne Jackson, President of the Womens Engineering Society, speaking at a conference "Women into Science and Engineering" in November 1983, stressed the urgent need for girls to develop practical "know-how", especially if they were considering a career in engineering.[67]

Frances Cairncorss, writing in *The Guardian,* put it like this:

> Cars, like all bits of machinery, work better in the hands of the confident. Confidence comes from experience. Most boys, by the time they leave school, have handled (either at school or at home) a lathe or a drill, or even an old Meccano set. When I left school I knew stem stitch and chain stitch, how to roll silk, and how to darn socks. But I was twenty before I changed a plug; 30 before I put in a Rawlplug alone. And I doubt if it's very different for most girls now...With more and more women living alone − through choice, through marital breakdown, through widowhood − we do no girl a favour by allowing her to leave school ignorant of the uses of pliers and screw drivers.[68]

Allegations against the circus arrangements did sometimes have an element of truth, but CDT had its problems long before the arrival of girls. Opening it up to girls did not spoil an otherwise flourishing and progressive situation. Indeed, most boys' schools were still in the vice-like grip of the century old tradition of woodwork and metalwork; very few had open plan workshops that encouraged fluidity and diversification.

The arrival of girls in the workshops following the enactment of the Sex Discrimination Act created for curriculum planners a dynamic for loosening traditional divisions, but few recognised or wanted to grasp the opportunity. Soon, weasel words linked indifferent performance and progress with girls. Nor did the benefits for boys studying traditional girls' subjects arouse interest even though boys enjoyed them. A Schools Council report might urge that: "Education should affirm the responsibility of men and women for child rearing and domestic tasks"[69] and *A Framework for the School Curriculum* acknowledged the need for education in "preparation for parenthood and adult role in the family life," but who listened?[70]

In those schools incorporating CDT, art and home economics within a faculty structure and with a coherent rationale, the circus system worked well. The work, usually planned as a designed-centred, practical problem-solving-activity, caught the imagination of most pupils. It generated an excitement with designing and making, with technology, with working in and manipulating

Table 10 GCE ORDINARY LEVEL RESULTS SUMMER EXAMINATION 1985

	Number of entries	Number awarded Grade A-C	Grade D	Grade E	Ungraded
BOYS					
Technical Drawing	47,720	24,059	5,848	7,487	10,326
Engineering Workshop Theory and Practice	4,871	2,933	711	733	494
Design and Technology	19,828	11,809	2,691	2,372	2,956
Woodwork	10,224	5,554	1,637	1,279	1,754
Metalwork	7,021	4,023	1,180	955	863
GIRLS					
Technical Drawing	3,724	1,622	489	702	911
Engineering Workshop Theory and Practice	77	38	8	22	9
Design & Technology	1,154	718	161	110	165
Woodwork	318	163	60	50	45
Metalwork	125	69	26	14	16

GCSE Mode 1
Subject entries

	Boys	Girls
Woodwork	47,057	1,539
Metalwork	40,198	645
Technical Drawing	73,382	5,237

a range of materials, thereby stimulating and developing an appreciation and understanding of the common elements that make up CDT and of essential evaluative techniques, so important in design project work. It worked chiefly because the staff, sometimes working in teams, emphasised the cohesiveness of the subject rather than concentrating on its disparate parts. Above all else they motivated their pupils. Surely this is the type of enriching, rounded educational experience required by youngsters of twelve or thirteen, not a sterile preparation for examinations that most will never take? It might even encourage more pupils, especially girls, to continue with CDT after their first compulsory stint is over.

CDT examinations − the invisible women

The girls who stream through the school workshops in the first two or three years of secondary education is almost everywhere reduced to a trickle by the time the fourth year is reached, and has all but dried up when 'A' levels loom. Table 10 spells out the examination statistics.

Table 11 shows the trend during 1973- 1985.[71] It should be borne in mind that the school population of examination age continued to grow until the early eighties. The combined figures (boys and girls) for woodwork and metalwork at CSE and 'O' level greatly exceeded the number of candidates who took Design and Technology. To convey an impression of a greater growth rate, statistics for the latter are often presented in terms of percentage growth. So misinterpretation may disguise the fact that a great deal of traditional woodwork and metalwork teaching goes on as before. Welcome as the new GCSE is, it does pose a problem of adjustment. Even in the face of official disapproval, craft examinations look likely to continue for years yet. The low number of girls taking CDT examinations is cause for dismay. In the early years these were not difficult to discover. Without foundation studies − which were generally not available to girls − it was almost impossible at first to take the subject to examination level. This is no longer the main barrier. The problems encountered by older girls now are: varying degrees of male prejudice; a marked absence of female role models; pressures from peer group expectations and approval; unsympathetic workshop environments; alien curriculum content; low teacher expectations; a widespread lack of confidence among girls and the low status and restricted currency value of many CDT examinations.[72] Those who bewail the low examination take-up rate by girls forget how limited woodwork, metalwork and technical drawing qualifications were in the past. They were bottom in the examinations league table along with home economics and needlecraft and were not accepted for University. They were scorned by the professions, ignored by the banks, written off by the Civil Service and other potential employers. One might assert that the situation is different today and to some extent it is. But the old attitudes have not been wholly laid to rest by public relations exercises and marketing campaigns.

Those responsible for recent examination changes have been understandably reluctant to square up to the fact that few academic high fliers went

Table 11

RESULTS OF CSE. ALL MODES 1973-1985

	1973	1974	1975	1976	1977	1978	1979	1980	1981	1982	1983	1984	1985
Technical Drawing													
Boys	53,657	66,950	66,400	60,297	70,409	73,461	82,793	84,180	85,189	84,547	78,968	71,800	67,111
Girls	583	852	838	889	1,538	2,126	2,793	3,157	3,563	4,404	4,554	4,662	4,743
Metalwork and Woodwork													
Boys	60,00	86,751	86,126	94,130	107,784	106,575	110,423	111,763	113,996	112,511	103,268	98,696	83,041
Girls	277	520	511	701	1,039	1,695	1,725	1,830	2,027	2,250	1,960	6,653	2,070

in for the traditional craft exams. Candidates were most likely to be noted for their diligence, perseverance and dependability, qualities not tested in traditional examinations. More often than not they were taught by teachers who did sterling work that went unrewarded, who imbued confidence and a sense of fulfilment and achievement which pupils did not get elsewhere. For most woodwork and metalwork candidates, GCE ordinary level and CSE was the end of the road. It enabled a minority to achieve their only taste of examination success; for others it helped pad out a modest offering of other subjects.

Although the status of traditional craft examinations might not have been high, they were a useful first step towards an apprenticeship. Recently this vocational route has been shared with growing numbers of candidates who have taken the popular City and Guilds examinations. Examinations taken for vocational reasons could benefit girls too. Instead of heading for women's jobs where work is monotonous, needs little or no skill and carries with it no access to training and promotion, girls should be encouraged to consider entering male-dominated craft industries and skilled manual trades. Both the EOC and the Engineering Council have expressed serious concern about the under-representation of women in the engineering industry. At present 94 per cent of all women who work in the industry are employed as operators, clerical staff or in unskilled trades. The situation in the building industry is equally bleak. Groups such as Women in Manual Trades energetically try to dispel some of the myths which surround this work, in particular that it requires super-muscular powers. Bricklaying, plumbing and carpentry are certainly physically hard jobs but are well within the capacity of women. Even in the skilled trade of electrician, where strength is not an issue, the first woman did not complete her apprenticeship until 1979 and few have followed.[73] In 1987 the construction industry reported that the percentage of women employed in skilled trades has hardly changed over the last ten years.

Ruth Miller summed up the reasons for the reluctance of many girls to entertain the idea of pursuing these jobs:

> Many jobs and school subjects which ordinary boys choose without needing initiative and confidence, require tremendous initiative and confidence from girls, thus making a nonsense of the simple equal opportunities concept. The girl who is willing to differ from her peer group to do technical drawing instead of housecraft, or who refuses to do secretarial studies when the school is expensively equipped to prepare her for the traditional job tramlines, has to be determined and enterprising. Rather special in fact.[74]

It might be thought Ruth Miller's argument has been countered by various MSC schemes which should achieve job diversification opportunities for girls that school programmes failed to do. But evidence suggests that these initiatives generally follow traditional sex stereotyped lines.

For girls contemplating taking CDT at 'A' level the problems were of a different order. The majority of candidates pursue 'A' level courses to achieve

Table 12

DESIGN AND TECHNOLOGY A-LEVEL

	1980		1981		1982		1983		1984		1985	
	BOYS	GIRLS	BOYS	GIRLS	BOYS	GIRLS	BOYS	GIRLS	BOYS	GIRLS	BOYS	GIRLS
Entries	841	106	990	116	650	139	643	85	669	41	721	46

TECHNICAL DRAWING, WOODWORK AND METALWORK A-LEVEL

	1980		1981		1982		1983		1984		1985	
	BOYS	GIRLS	BOYS	GIRLS	BOYS	GIRLS	BOYS	GIRLS	BOYS	GIRLS	BOYS	GIRLS
Technical Drawing Entries	2,748	73	2,706	60	2,936	88	3,105	95	2,731	101	2,487	108
Entries Metalwork Woodwork	583	7	537	11	535	11	509	10	421	14	288	8

entry qualifications for higher education or for a job. In the post-Sex Discrimination Act years, 'A' level CDT led nowhere − with the exception of colleges of education with CDT departments. One exasperated head of department expressed the problem in a letter:

> ...without the acceptance of the subject at 'A' level as an entry qualification for graduate courses at Universities and Polytechnics you are living in 'cloud cuckoo land.' The comparatively few teachers of the subject, myself included, who with difficulty, have got this subject included in the curriculum of a sixth form college, are faced with the ever recurring problem of encouraging those who are responsible for the admission of students to opt for this area of study. The problem then is to establish who will accept these qualifications and for what courses...

> It would seem the only area that accepts these subjects are teacher training institutions so that they can train more people to teach Design and Technology. Even if Design and Technology at 'A' level is combined for example with maths and physics, those students would get places on the strength of their maths and physics alone.

No wonder the total number of girls taking woodwork and metalwork barely reached double figures at best, as shown in Table 12.[75]

The Standing Conference on University Entrance's (SCUE) recognition of Design and Technology 'A' levels (not woodwork and metalwork) for university entrance appeared to be a breakthrough. But it was only a beginning. Few within CDT appreciated that individual university departments, faculties and schools determined their own entrance requirements, independent of advice from SCUE. Extensive enquiries suggest that, apart from teacher training, only rarely is an applicant awarded a university place on the strength of a pass in CDT. Nevertheless, the fact that it is now sometimes accepted as a third 'A' level is a step forward.

Unfortunately, soon after the SCUE decision, university cuts put a premium on places. To maintain academic standards and control, student entrance requirements were raised. So these are not easy years for admission tutors to engage in even cautious experiments.

In 1985 the SCUE backtracked on its decision and advised sixth formers against taking certain 'A' levels.

> You need to realise that, as George Orwell said of the animals in *Animal Farm,* some are more equal than others.[76]

SCUE warned that, as a rule, sixth formers who intended to apply for a university place should avoid "unconventional" 'A' levels. By these they meant Design and Technology, also computer science, electronics, human biology, and home economics. Brian Heap, the expert on university entrance, endorsed this view.[77] Margot Norman, education correspondent, summed up the position in the *Daily Telegraph.*

Technical and vocational subjects, especially those involving a strong element of practical skill, have been virtually outlawed by the universities.[78]

The criticism against CDT will be best overcome by considering it, not condemning it as prejudice. In the end it boils down to a question of rigour. Errors have been found in technology examination questions and boards would be advised to have a moderator who is an engineer or technologist to prevent such mistakes. Students who have Design and Technology at 'A' level often found this less demanding than mathematics or physics. We hear of students who passed 'A' level woodwork, metalwork or technical drawing after a year in the sixth form, impossible in other subjects. These are problems of long standing.

Whilst 'O' level numbers are slowly building up, they are not providing a substantial base for increasing 'A' level entries. They reached a peak in 1981 and have since fluctuated downwards. In 1984 the total number of candidates was 740 of whom 41 were girls. For comparison there were 772 entries for photography. At first Design and Technology figures were too small to warrant a special category in official DES statistical tables. The impact of the SCUE and Brian Heap's advice is still to be felt. Fleetingly it looked as if a greater number of academically able girls were being encouraged to continue with their studies of CDT but now some of the steam has gone. From an individual girl's standpoint the problem does not change. Why should she pursue a traditional male subject of limited value when alternative subjects will do more to advance her career opportunities?

Girls and CDT – a media event

Opening up school workshops rescued practical subjects from almost a century of popular oblivion. The novelty of girls taking boys' subjects attracted a great deal of publicity, not all of it helpful.

In the circumstances it is not surprising that the media – popular and quality Press, radio and television alike – reported practical activities in traditional terms and even Shirley Williams displayed ignorance of terminology when she said "...we cannot rest until...any girl in any part of the realm may choose metalwork or carpentry".[79]

The *Daily Express* informed readers that "At Parklands (a girl's school) they are introducing craft studies this year for the first time and a teacher of technical studies has been appointed. Next year they will be able to offer woodwork and metalwork.[80] *The Guardian* told readers that "In all too many schools woodwork and metalwork are still reserved for boys and needlework for girls."[81] and Six years later *The Observer* survey 'Britain Observed' still referred to woodwork, metalwork and technical subjects.[82]

The Equal Opportunities Commission in the seventies almost always referred to woodwork and metalwork.[83] The fairest representation of practical subjects at the time occurred in the case of Whitfield v the London Borough of

Croydon (1979): CDT rarely surfaced in the reporting, which had an almost Victorian ring about it. Mrs Jean Whitfield sought, unsuccessfully, to prove that her daughter Helen had been unfairly discriminated against under the Sex Discrimination Act. The Equal Opportunities Commission backed her initially, but later withdrew its support. Even professional journals produced headlines like: "Croydon win court case on woodwork for girls" *(Education);* "Girl denied carpentry claims discrimination" *(The Teacher)* and "Girl carpenter loses sex bias case" *(The Times Educational Supplement)*[84]

Kenneth Baker in a 'Wogan' interview in April 1987 resorted to explaining CDT in terms of woodwork and metalwork. One suspects that he, like Shirley Williams, knew his audience.

Involving girls in CDT

Strategies to make CDT more girl friendly have been suggested for some years. Increasing the involvement of girls in CDT does not rank high on most CDT teachers' lists of priorities. How many, for example, have a copy of the EOC's *Equal Opportunities in Craft, Design and Technology* and follow the working party's recommendations?[85] How often do girls and CDT feature in INSET programmes?

Many proposals for reform start with the primary school, or even the nursery. Girls, it is advocated, should forsake their Cindy dolls for mechanical and constructive toys which, it is hoped, will do much to develop manipulative ability and sense of spatial relationships. The latter, as is well known, is one of the few areas in which girls consistently underscore in tests when compared with boys.[86]

Shifting the beginnings of CDT into the primary schools is one aspect of CDT teaching which attracts universal commendation. Not that much goes on in them at present. The DES survey *Primary Education in England* expressed disappointment at the lack of provision and recommended providing "opportunities to undertake some work with wood and other resistant materials and to learn to handle tools and techniques associated with them."[87]

> Much of the work in primary school can develop positive attitudes to designing and making activities of either an aesthetic or technological nature. Children are fascinated by things which work, but rarely are working models built as part of a topic or project.[88]

The EOC enquiry into CDT teacher training, similarly recommended that:

> All primary and middle schools should provide CDT related experiences for all pupils. Although CDT will probably not appear as a separate subject on the primary school timetable, the problem-solving approach which is the basis of CDT, together with experience of simple design method and constructional skills, and a basic knowledge and understanding of technology can and should be fostered in all primary and middle schools.[89]

All of these enrich the educational experience of both boys and girls, but not all are put into practice. How many women teachers or men with no previous experience can use simple hand tools in a way which inspires confidence and conforms to safe working practices or make simple working models to demonstrate scientific or technological principles? The effective presentation of practical work requires flair, good organisation and more time in preparation than ordinary classroom work. Nothing is more demoralising than to come unstuck when demonstrating in front of a class of inquisitive, enthusiastic children. If practical work is to have a significant place in the primary curriculum, time and resources for in-service training will have to be found.

As the BBC series 'Junior Craft Design and Technology' showed, television can provide teachers, hesitant about introducing practical work, with a useful survival kit. Each programme concentrated on a topic illustrating a basic scientific or technological principle. Featuring both girls and boys, women and men teachers, the series gave pupils a genuine experience in problem solving, and took them through a variety of craft skills and processes. Girls also figured prominently in the ITV series, 'Craft, Design and Technology', though this was a less useful teaching aid as it lacked structure.[90]

A number of imaginative schemes to stimulate interest in CDT and science among girls have been piloted by LEAs, firms, training and professional associations and educational institutions.[91] They range from the City of Sheffield's Education Department project to attract women into jobs traditionally reserved for men − especially manual trades − to the Lincolnshire and Shropshire intiatives (now being widely copied) designed to give third year girls an insight into technologically oriented careers and to provide them with "hands-on" practical experience. One of the most ambitious projects was the Girls into Science and Technology Project (GIST). Based on ten co-educational schools in Greater Manchester, it was directed by Judith Whyte at Manchester Polytechnic from 1979 − 1983. Its aims were:

> to investigate the reasons why girls underachieved in physical science and the technical crafts and to reduce this under-achievement by encouraging teachers of science and CDT to modify their teaching methods and curriculum to increase girls' involvement.[92]
>
> It was hoped that this would lead to more girls opting for traditionally "masculine" subjects and encourage more girls to pursue careers in science and technology. The strategies used included;

1. teacher workshops to modify and develop curriculum materials in science and CDT to enhance their appeal to girls;
2. observation of teacher-pupil, pupil-pupil interactions in science and CDT classes;
3. identification of ways to prevent girls being discouraged;
4. parents evenings to heighten awareness of the implications of subject choices;

5. revision of option systems and booklets to remove any in-built sex bias;
6. the establishment of the VISTA programme.

The VISTA programme sought to give young girls access to successful women engineers, scientists, technicians and craftspeople. Not only were there few craftspeople around but they had difficulty getting time off and tended to lack the self confidence to project themselves effectively in front of the girls.

It is too early to assess the effectiveness of these schemes in changing attitudes and extending opportunities for girls to succeed in non-traditional fields. Many widely promoted projects simply fade away.

The GIST's team exposed Victorian attitudes flourishing in school workshops. Judith Whyte heads one chapter "Craft, design and technology: a hard nut to crack" and she concludes

> Whereas in science a large body of research evidence offered real hope that girls in mixed schools could achieve much more in the physical sciences than they were doing, there had been relatively little investigation of the crafts curriculum. While science teachers were readily accepting factual evidence and prepared to adjust their professional practice accordingly, craft teachers do not have the same tradition of research-led curriculum development.[93]

Martin Grant concurred:

> ...significant changes in the attitudes of girls towards technology and in their participation in courses and activities at secondary level are unlikely to be achieved without major reform of the CDT/technology curriculum.[94]

Patently, there is an enormous task ahead. A straw poll of more than fifty CDT teachers over the 1987 Easter period [95] revealed that most had never heard of the GIST Project or had only the vaguest idea of its purpose. More waves will have to be made before the 'ripple' effect Judith Whyte hopes for is achieved. Margaret Maden at an ILEA conference saw the wider involvement of women in CDT as a matter of "social equity and justice", saying that "girls should not be excluded from a subject that can give access to better paid, traditionally male-dominated jobs, and, more generally, to participate in any subject of broad educational value."

The future of CDT depends on its becoming a rigorous, acceptable and attractive subject for intelligent and articulate girls. The fight to bring this about in mixed schools (the only ones affected by the Sex Discrimination Act) has hardly begun. Perhaps the extension of CDT into single sex girls' schools is the next battle. Troops are needed: sympathetic CDT teachers of both sexes who can generate confidence and a belief that their subject is worthy of study. Without half the school population, CDT will remain a peripheral minority subject.[96]

References
1. *The Schoolmaster* 37 (5 April 1890), 501
2. P. Magnus 'On Manual Training' *The Contemporary Review* (November 1886), 696
3. Royal Society of Arts, B.W. Richardson 'National Necessities as the Basis of National Education' *Journal of the Society of Arts* 30 (12 May 1882).
4. J. Crichton-Browne 'Report to the Education Department upon the alleged over-pressure of work in public schools', with a memorandum by J.G. Fitch *House of Commons Accounts and Papers* LXI (1884), 3.
5. School Board for London *Report of the Special Committee on Over-pressure in Schools of the Board* (1885).
6. S. Maclure *One Hundred Years of London Education 1870-1970* (1970), 14. Allen Lane.
7. *The Schoolmaster* 25 (12 April 1884), 524.
8. For further information on the Arts and Crafts Movement see G. Naylor *The Arts and Crafts Movement* (1971) Studio Vista; L. Lambourne *Utopian Craftsmen* (1980) Astragal Books.
9. J. Ruskin *Stones of Venice* (1853) Everyman Library Vol 2. 138-211.
10. J. Ruskin *Time and Tide* (1867),161. Dutton.
11. Laborare est Orare 'Why manual training should be taught in schools' *The Manual Training Teacher* 4 (September 1904), 5.
12. See C.R. Ashbee *A Short History of the Guild and School of Handicraft* (1890); F. MacCarthy *The Simple Life: Lund Humphries* (1981); A. Crawford, C.R. Ashbee (1985) Yale University Press.
13. London County Council, H. Llewellyn Smith *Report to the special Committee on Technical Education* (1892).
14. *The Times* (18 June 1892), 18.
15. Equal Opportunities Commission *Formal Investigation Report: Craft Design and Technology Teacher Training* (1985), EOC, IV.
16. E.L. Jebb 'Handwork for Children' *The Nineteenth Century* 12 (October 1882), 602-612.
17. School Board for London *Minutes of Sub-Committee on Technical Education* 16 February (1885).
18. *The Times* (25 November 1884).
19. School Board for London *Minutes of the Sub-Committee on Technical Education* 16 February (1885).
20. J.B. Penfold 'Learning the Lessons of Beethoven Street' *Education* 165 No.16 (19 April 1985) 355.
21. The North Westminster Community School *One hundred years of CDT* (October 1985)
 The Times (14 October 1985)
 The Guardian (15 October 1985)
 The Times Educational Supplement (18 October 1985)
 J. Eggleston 'Craft, Design and Technology – the uncertain future' in A. Cross & P. McCormick (Eds) *Technology in Schools* (1986), 162-164.
 Open University Press
22. 'Well-known Teachers at Work – Mr. John W. Tate' *The Practical Teacher* 15 (November 1894), 242.
23. C.H. Bellman *Cornish Cockney* (1947), 26.
24. *Ibid.*, 7 (March 1887), 6.
25. School Board for London *Report of Finance Committee* (25 November 1886)
26. Reported in *The Schoolmaster* 29 (29 May 1886).
27. *The Practical Teacher* 5 (October – 7 March 1887).

28. *Ibid.*, 7 (March 1887), 6.

29. *The Journal of Education* 9 (April 1887), 71; *Some National and School Board Reforms* (1887)

30. *The Journal of Education 9 (April 1887), 190; 0 (May 1887), 235.*

31. *The Educational Times* XLI (2 November 1888), 438.

32. *The Journal of Education* 10 (1 February 1888), 73.

33. *Ibid* 10 (1 September 1888) 432.

34. *Sloyd or Hand-Craft* No.1. (July 1890).

35. *The Fortnightly Review* 4 (February 1887), 315
 The Saturday Review (25 March 1887), 448.

36. *Journal of Education* 10 (1 December 1888), 562.

37. *The Times* (22 May 1888).

38. Quoted from A.J. Evans *A History of Education in Bradford during the period of the Bradford School Board.* (M.A. thesis University of Leeds 1947) unpublished.

39. 'Technical Education in Board Schools' *The Contemporary Review* 53 (May 1888), 672-684.

40. Grace Johnstone, 'Technical Education in Elementary Schools and out of them' *Journal of Education* 11 (1 November 1889), 568-571.

41. 'Manual Instruction in School with Special Reference to the Swedish Slojd System' *The Educational Times* 42 (1 January 1889), 13-17.

42. *Hand and Eye* first published in October 1892.

43. National Union of Teachers, 'Manual Training — Evolution not Revolution' *National Union of Teachers Report* (1890), Lix.

44. *The Record of Technical and Secondary Education* (January 1982), 201.

46. 'Six Weeks at Naas' *The Schoolmaster* 40 (19 December 1891), 1021.

47. W. Goetze 'Report of the Present State of Manual Instruction in Germany' *Report to the Education Department of the Colony of New Zealand* No.22 (1885), 20-30.

48. JBB 'Leipsig v Naas' *Journal of Education* 12 (1 July 1890), 360-361.

49. Reports of the deputation were printed in *The Schoolmaster* 44 (23 December 1893), 1105; *The Journal of Education* 16 (1 January 1894), 15; *The School Board Chronicle* 5. 3 February 1894), 132; *Hand and Eye* 2 (15 October 1893), 74.

50. M.A. Smalley and J.B. Penfold unpublished DES/Shoreditch College *Report Opportunities for Women in Teaching Craft, Design and Technology* (1980).

51. Equal Opportunities Commission. *Formal Investigation Report; Craft Design and Technology* (1985),8.

52. *Ibid*, 85.

53. Equal Opportunities Commission C. Seale, J. Bloomfield and J. Pratt 'Curricular Differences in Secondary Schools' *Research Bulletin No.6 Gender and the Secondary School Curriculum* (1982). 16-29.

54. M. Harychi 'Women in Industrial Education' *Man, Society and Technology* (February 1979) 8.

55. DES *Aspects of Secondary Education in England* (1979) HMSO

56. *The Guardian* (28 May 1978)

57. For findings in respect of ILEA schools see JB Penfold and MA Smalley 'A Bridge to Brunel' ILEA *Contact* (November 1977)

58. J.B. Penfold and MA Smalley 'Report, Durham County Schools, Conference for Heads of Design Technology Departments, New College, Nevilles Cross, Durham (30 June 1978) '*Craft Design and Technology in Durham Schools* (Autumn 1978)

59. *The Times Educational Supplement* (30 June 1978)

60. *Ibid.,* (14 July 1978).

61. S. Delamont *Sex Roles in the School (1980) Methuen 49.*
 See also S. Delamont 'The Conservative School? Sex roles at home, at work and at school'
 in J. Whyte (Ed) Gender, science and technology Inservice handbook (1985) Longman.

62. British Educational Research Association Annual Conference C.J. Randall *'Gender differences in pupil-teacher interaction in workshops and laboratories'* (1985).

63. D. Spender 'Talking in Class' in D. Spender and E. Sarah (eds) *Learning to Lose; Sexism and Education* (1980) Women's Press.

64. Report, 'Sex differentiation and schooling Conference' *The Times Educational Supplement* (11 January 1980).

65. J.B. Penfold and M.A. Smalley 'Design Technology Shortage' *The Times Educational Supplement (23 August 1978).*

66. *DES HMI Series: Matters for Discussion 13: Girls and Science (1980, 11. HMSO*

67. *Standing Conference on Schools 'Science and Technology Conference 'Women into Science and Engineering* (17 November 1983).

68. F. Cairncross 'Can the hand that rocks the cradle grip a mole wrench?' *The Guardian* (30 August 1982).

69. Report in *The Times Educational Supplement* (5 December 1980).

70. DES *A Framework for the School Curriculum* (1980).

71. DES *Statistics of Education: Statistics of School Leavers GCE and CSE* 1983,4,5) HMSO.

72. For further information see EOC *Equal Opportunities in Craft, Design and Technology* (1983) EOC; Schools Council *Newsletter NO. 3. Reducing Sex Differentiation in School* (November 1982) J. Catton *Ways and Means: The Craft, Design and Technology Education of Girls* (1985) Longman.

73. Women in manual jobs became a popular media topic. See L. Heron 'Not quite ladylike' *The Times Educational Supplement* (26 May 1978); B. Phillips 'Women can break into male trades' *The Observer* (10 July 1977); G. Sheridan 'Apprentice handicap' *The Guardian* (8 February 1979; BBC play 'Leila' (May 1978) had the theme of a married woman determined to retrain for a skilled job as a mechanic.

74. R. Miller, 'Not for Ordinary Girls' *The Times Educational Supplement* (7 December 1978).

75. DES *Statistics of Education : Statistics of School leavers GCE and CSE* (1980-1985) HMSO.

76. Standing Conference on University Entrance *Choosing A- levels for University* (1985).

77. B. Heap *Degree course offers 1986* 1986) Careers Consultants.

78. M. Norman 'Black-list of 'A' levels for university entrance *The Daily Telegraph* (18 May 1985).

79. *The Daily Telegraph* (23 October 1978).

80. 'Report on Sexism in Class' *The Daily Express* (22 November 1978).

81. 'Slugs and snails, sugar and spice' *The Guardian* (9 May 1978).

82. *The Observer* October 1984.

83. *The Times Education Supplement* (14 April 1978).

84. *Education* 4 January 1980); *The Teacher* (21 December 1979); *The Times Educational Supplement* (28 December 1979).

85. EOC *Equal Opportunities in Craft, Design and Technology* (1983) EOC.

86. E.E. Maccoby and G.N. Jacklin *The Psychology of Sex Differences* (1975), 351-2 Stanford University Press.

87. DES *Primary Education in England* (1978) HMSO.
88. EOC *Equal Opportunities in Craft, Design and Technology* (1983)
89. EOC *Formal Investigation Report Craft Design and Technology* (1985).
90. A. Suffolk 'Evaluating the CDT Series' *Studies in Design Education Craft and Technology* 16, (Winter 1983) 29-34.
91. A comprehensive list is given in Standing Conference on Schools 'Science and Technology' S.L. Bullivant and C.L. Onions *Examples of initiatives to encourage girls and women to consider careers in engineering* (1983).
92. A. Kelly, B. Smail and J. Whyte *GIST Initial Survey – Results and Implications* (1983) See also EOC B. Smail, J. Whyte, A. Kelly 'Girls into Science and Technology, the First Two Years' *EOC Research Bulletin No. 6 – Gender and the Secondary School Curriculum* (Spring 1982) 1-16.
 For a full list of work relating to the GIST project see J. Whyte *Girls into Science and Technology* (1986) 278-280. Routledge & Kegan Paul.
93. *Ibid.*, 141-142.
94. Girls and Technology Information (GATE) BP School teacher fellowship, M. Grant. *A summary of the work and findings of the project to date* (June 1984). 3.
95. B.K. Down 'CDT and Equal Opportunities' *Studies in Design Education, Craft and Technology* 19 (Winter 1986), 18-25.
96. J.B. Penfold 'Roundabouts and Swings' *The Times Educational Supplement* (17 October 1986), 37.

Chapter 3

TEACHER EDUCATION – SHAMBLES OR STRATEGY?

At a time when CDT is basking in unprecedented sentiments of warmth, teacher education programmes to supply its changing needs are confused. Where are the teachers who will transform the subject from its heritage of woodworking for the weak and metalworking for the mediocre to a curriculum packed with design and technology problems designed to tax its strongest takers?

Most teachers 'trained' when the emphasis was on manipulative skills, latterly laced with good design teaching. The same applies to the higher echelons: few of the H.M. Inspectorate, advisers, teacher trainers hold technological or design qualifications. The difficulties this creates tend to be played down and the harsh realities left unsaid. How can technology teaching expand when the combined output from all teacher education institutions produce no more than 100 students per year who have undergone a rigorous technological course? Add to this the recent unrest in the profession and it is difficult to imagine a future in which many young people with technologically marketable skills elect to become teachers. There is no concerted action to deal with the CDT teacher shortage and authorities have to rely on short-term cosmetic expedients and in-service training. A clutch of LEA successes and the occasional TVEI triumph should not disguise the fact that, nationally, technology teaching remains thin on the ground. Without appropriate qualified teachers, the high hopes currently pinned on CDT will inevitably be dashed. Late Victorian initiatives correspond remarkably with today's debate and nowhere is this more pronounced than in teacher supply and teaching method. How, and by whom, manual instruction should be taught were fiercely debated a hundred years ago and outcomes determined the provision and style of workshop teaching until well into this century and still influence the scene today.

Despite widespread interest, the London School Board's Beethoven Street experiment came to an abrupt end when the Government Auditor proposed to surcharge a number of Board Members individually for permitting expenditure on an item outside the existing Code. That was in 1886. Cockney children

being taught woodwork in a converted shed in a corner of the playground by the school caretaker may not have been the most illustrious beginning for CDT but this was not how the Victorians saw it. It seemed eminently sensible to them that manual instruction should be taught by a skilled artisan who had served his time as an apprentice, under the direction of the headmaster. Who else was there? Sloydists, following the philosophy of Otto Salomon that practical work should be taught by trained teachers, had yet to make their voices heard. All this was to change when the London School Board next ventured into manual instruction teaching.

The Joint Committee of the School Board for London and the City and Guilds Institute.

To circumvent the problem of illegal expenditure, the Board wrote to the newly founded City and Guilds of London Institute for financial help. Fortunately the Institute, with funds donated by the Drapers'Company announced its willingness to make a grant of around £1000 towards the cost of equipping and maintaining a number of manual training centres. A Joint Committee with representatives from the City and Guilds Institute, the School Board for London and the Draper's Company, was set up to organise the scheme. The experiment, which lasted from 1887 to 1900 was the most far-reaching and influential the subject has ever seen – far greater than the more recent Schools Council projects.[1]

"Here is an excellent shed"

The Committee had first to determine the scale and accommodation. It decided to limit the experiment initially to six schools: three north and three south of the Thames (not very different from the original TVEI proposal). Schools were inspected for their suitability and the Committee's report clearly indicate which pupils it believed would most benefit from manual instruction.

Thus Summerford Street School in Bethnal Green, was described as..."a crowded school in a very poor neighbourhood. There is one vacant classroom in the Girl's Department to which access could be obtained for the Boys without much difficulty and it is possible that the adjoining classroom can also be obtained. The class of children attending this school would recommend it for Manual Training Classes."

Similarly the Board Street School, Ratcliffe, also found favour in the Committee.

> Here is an excellent shed, admirably suited for the purpose of the Committee. The neighbourhood is crowded. Collingwood and High Street School are in immediate contiguity. If a few extra lights were put in the roof of this building nothing further would be required. Your sub-committee strongly recommend this school as a centre.[2]

The Committee's endorsement of the centre system, with neighbouring schools sending pupils to an off-site workshop rather than having workshops in

each school formed the pattern copied by school boards for years to come. Though it made intensive use of resources and staff in short supply, it had profound consequences for the subsequent development of the subject. Manual training became separated from the existing elementary school curriculum, taught by instructors physically removed from mainstream education, instead of being integrated into it. Long-standing retired handicraft teachers describe how they would remove the glue pot from the gas ring, and replace it with their kettles when the boys left. Centres persisted until the 1950's and '60's.The author remembers a teaching practice in a London double centre (in which two classes were taught at opposite ends of one large workshop) where he experienced such isolation himself.

The Appointment of Instructors: "Artisan" takes a hand
The Appointing of instructors to run the centres was the next problem. The Joint Committee decided that a trained teacher who had undergone a course of instruction in manual training should be in charge assisted by a skilled artisan. This shows that sloydists had influenced the School Board. However, the advancement of teachers at the expense of skilled tradesman provoked a furious response from one correspondent to the *St. James Gazette*.[3] From the tone of the introductory comment the newspaper clearly agreed with him. The letter was to influence the course of workshop teaching in this country:

> We received the following communication from "An Artisan"; and we specially commend it to the notice of the council of the Technical Institute. The members of the London School Board are probably quite incorrigible.
>
> The long continued depression of trade in England has had one good result: it has directed attention to the need for technical education and manual training among the youth of the classes who are for the most part destined for manual occupations. Various individuals and bodies are taking action in this matter; and it is a point of great importance that any well-intentioned effort in the interest of technical education should not be marred and discredited by blundering of any sort.
>
> The City and Guilds of London Technical Institute is one of the bodies that have taken up this question. Among other things they have made an offer to the School Board for London to "pay at least two instructors who have duly qualified to give instruction in manual training classes." The Board has accepted the offer; and a joint committee of the Board and the Institute has been formed to deal with the matter. This committee has decided to try as an experiment, for one year, the establishment of manual training classes; and it has just issued a circular announcing its intention to appoint "at least two instructors" for these classes. The circular is sent out by the School

Board, bears the Board's stamp, and is signed by the clerk to the Board. It is addressed to headmasters of Board schools, with a request to bring it under the notice of their assistants, as the appointment is to be made in the assistant-master class.

This limitation of the area of selection is about as brilliant as example of how not to do it as could be conceived. The instruction given by such instuctors would be of truly barmecide order. Among the assistant masters of the Board there are doubtless a number holding the Science and Art Department certificates for mechanical drawing or "applied mechanics"; and by diligent search there might possibly be found "at least two" assistant-masters who could do (say) a little amateur fret-saw work. That would be the most and best it would be! The Science Department's certificates have reference to the "bookish theorie" only, and they are held in larger numbers by operative artisans than by most schoolmasters, whether head or assistant. The gaining of such a certificate is proof of at least fair general education and intelligence; while other artisan holders of them are also trained, skilful and experienced handicraftsmen. The proposed manual training is in relation to skilled labour and it seems to me glaringly obvious that the best manual instructors that could be selected for the youths of our working classes would be picked men of the leading handicraft trades. It is men of that stamp who have been chosen as manual instructors at Eton and King's College, and it may be pretty safely taken for granted that the same method of selection has been followed at any other educational centres at which there has been an endeavour to give practical manual instruction to students. The salary of an assistant-master under the School Board runs as high as £150 a year and if the joint committee of the Board and the Institute, instead of issuing the remarkable circular quoted above, had put advertisments in the *Engineer* and the *Builder* offering £150 for instructors of manual training classes, they would have placed themselves in a position to chose from hundreds of well-qualified applicants, men of good general and technical education and proved competency in handling tools. It may be confidently asserted too, that among such men could be found numbers who even as oral demonstrators would be infinitely superior − in this particular connection − to the average assistant schoolmaster.

The character of the joint committee is highly suggestive of the School Board having managed to get the matter of the appointment into their own hands. On that hypothesis the circular would not be too hard to understand. It would be quite in the Board's style, and would probably mean the selection of ill-qualified instuctors in the first instance was intended to pave the way to the creation later on of some

such post as that of an instructor of instructors. But nominally, at any rate, the Technical Institute is in part responsible for this circular, and if its partial responsibility is more than nominal then the circular is certainly a wonderful document. For surely there must be upon the Council of such an institute men who know as well as they know light from darkness, that the proposed limitation of choice of instructors is calculated to make the so called manual training classes an utter delusion.

One would have expected from the Technical Institute strenuous opposition to a limitation palpably injurious to the interests of industrial technical education. As the institute has undertaken to pay the salaries of the instructors under the joint committee scheme, it may be said that it has a perfect right to do what it likes. That may be so in a sense, but not in a good one. Technical education in England has become a question of national importance; and certain it is that the "experiment for one year", if carried out on the lines laid down by the joint committee, will give good results – or rather non-results – that will do material injury to the cause of technical instruction.

The instructors have not yet been appointed; there is still time to amend the scheme; and it is sincerely hoped that the council of the Technical Institute will take second thoughts in the matter.

Professor W.C. Unwin, who was responsible for the manual instruction classes for teachers at the Finsbury Technical Institute, defended the Board's position. He explained that experience in Sweden has shown that manual instruction was best left in the hands of ordinary schoolmasters.[4] This cut no ice with "Artisan" who countered by attacking the stupidity of appointing teachers to the vacant posts.[5] Comparing the qualifications of the rival applicants, he insisted that the artisans were vastly superior to the teachers even in the schoolmasters' own field, that of "certificate holding". Simply on the facts "Artisan" concluded that

> The position with regard to the appointment of these instructorships is so preposterous as it stands that it is scarcely uncharitable to suppose that there must be "something behind it."

This time "Artisan" drew blood. H.C. Saunders, Chairman of the Executive Committee of the City and Guilds Institute, in a further letter to the *St. James Gazette* denied that the Institute had been influenced by "Artisans" letter, but he went on to announce that the committee had been so impressed with the qualifications of one artisan applicant that it had decided to appoint one artisan instructor and one teacher.[6] "Artisan expressed his partial satisfaction with the compromise, believing that he had obtained an important concession from the London School Board.

Who was "Artisan"? So well informed was he of the Joint Committee's proceedings that it could well have been Sir Philip Magnus. Certainly the stance adopted by "Artisan" paralleled that taken up by Magnus. Solomon Barter, the successful artisan applicant, could not have wished for a stronger champion than Magnus. With Magnus's backing Barter became the most influential teacher, organiser and author the subject has yet produced. Barter himself gave details of his background to the Irish Commission on Manual and Practical Instruction:

I was trained as an artisan. My father was managing foreman to a very large builder, one of the largest in England; and I was taught early in my life to draw, and early in life I became a foreman and designer in our building work; I had charge of some hundreds of men. I became a teacher under the Science and Art Department for this training...these classes have been of immense benefit to the artisans...

It is said in London that I am the best English carver in London, and I certainly have been a Sheraton designer for the last fifteen or twenty years. My father was a magnificent craftsman and my mother was a teacher, and I had the carver's tools put in my hands when I was not five years of age, and at sixteen I was carving and modelling under George Smith, at nineteen I worked the chimney pieces at Eaton Hall, at twenty-two I took charge of a shop, at twenty-five I was a designer.[7]

Barter's credentials as a craftman were impressive and the first wave of artisan instructors recruited by the Joint Committee were of the highest calibre and included some of the country's foremost craftsmen. Alfred Whillier for example, gained first class passes in the Carpenter's company examinations and won its much prized Bronze medal. Not that the Joint Committee was prepared to advance his career prospects, so he left for a post with the London School Board. Richard Wake was the first artisan ever to pass first class in every subject in the examination, for which the Carpenter's company awarded him its Silver Medal. Wake went on to make "considerable additions to my qualifications to the extent that now I hold higher qualifications in Carpentry and Joinery than any other person in the United Kingdom."[8]

The artisan instructor or the teacher
The log book of the Joint Committee enables us to compare directly the careers of Solomon Barter, the highly skilled ex- tradesman and John Pearson, the gifted London School Board teacher. Both earned praise in the log book entries from the numerous visitors who came from Parliament, from school boards and headmasters all over the country, and the United States, India and Australia. Observing Barter teaching, Sir Henry Roscoe declared himself "much pleased with the admirable course of manual instruction. It must be widely extended."
Other typical comments included:

A brief inspection, and a conversation with the master, gives me a very high estimate both of the plan of instruction and the practical results secured.(Geo. W. Atherton, State College, Pa., U.S. 8 May 1888).

...their energetic and intelligent instructor Mr J.C. Pearson, who appears to me to have adopted a very sensible and rational plan in requiring from each boy a working drawing of what has to be done before allowing him to proceed with the work itself. I consider the experiment a great success. (Thos. C. Howarth, Headmaster, Summerford Street School 1888).[9]

The earnestness with which the boys work is most satisfactory. Most of them, too, are acquiring the ability to work independently. Mr Pearson's teaching is thorough, based upon true principles and successful.[10] (William Ping, Headmaster, John Addey's School Deptford 1888).

The monthly reports that Barter and Pearson were required to submit to the Joint Committee also demonstrate their very different approaches. Barter's reports were factual and detailed, concentrating on his pupils' progress in handling tools and making joints. In contrast Pearson, at times less diligent in this respect − for which the Committee duly admonished him − perceptively highlighted educational and teaching issues. On one occasion he recorded:

From the time of the commencement of the classes, I have critically watched the individual ability the boys show for this kind of work. Of course, there are a few instances in which the boys seem quite unable to turn out good work; just as, in ordinary school work there are *some* boys who never gain facility in using a pen or pencil. Directly opposite to such there are not a few who show more than ordinary aptitude.

For the rest, I find that the boy who "will" do the work successfully, "can" do so; in short, that such an exercise as "sawing to a line" or doing anything else in which "care" is the main necessity for ensuring success.[11]

One of Pearson's most telling observations concerned the difference between teaching and instructing − a difference of approach that has dogged the subject ever since:

In these Object Lessons there must of necessity be a certain amount of "telling of facts", but wherever possible, *I introduce a train of reasoning.* All lessons of Classification serve well for this latter. As an instance:- I must "tell" that walnut is found in Europe, Asia, and America; but I "educe" from the boys that a bradawl say, must be classed with "wedge-shaped" boring tools, or, that, as a wedge forces the fibres apart if used longitudinally and so splits the wood, therefore a bradawl being a wedge-shaped tool must be used so as to "cut" these fibres transversly. I offer these simple instances to illustrate the "use" to which I am putting the Object lessons and Demonstrations; and trust that I am effectually meeting the wishes of the Committee in regard to making the course of instruc-

tion a means of "training the intelligence" as well as the boys gaining deftness in using the tools.[12]

Pearson may have hoped to persuade the Committee of the educational value of his approach but a careful reading of the minutes suggest that some of its members were far from convinced. Those who wanted essentially a form of vocational training, despite all their protestations to the contrary, tended to have more affinity with the views of Barter. We can see this when Pearson observed how his young pupils (they were smaller than their counterparts of today) struggled with man-sized tools and suggested that:

...some of the tools might with advantage, have been smaller and lighter; the plane and the saw. The weight of these tools is greater than many of the boys can control sufficiently well to produce good steady work. Planes and saws of about three-quarters the size and weight of those presently in use, would in most cases result in greater mastery of the work.[13]

When Barter was asked for his observations on Pearson's proposals he declared that:

The golden rule for the use of all tools is to have them as large as possible. Boys never use their tools with the steadiness of men, nor can little boys work with as much certainty, and if the tools are made smaller the results will not be as satisfactory as at present. For instance, the smoothing plane is almost useless in the hands of little boys, though the plane is smaller, and only half the weight of our jack planes. I certainly think the best feature of the existing tools, as a whole is their size. I consider it admirable and would recommend no change.[14]

The committee deferred to Barter's advice. Even when Pearson later asked for permission to conduct a limited experiment with smaller tools, the committee refused. It was only after Barter changed his mind that his indispensable man-sized jack planes were replaced with smaller, lighter 'technical pattern" planes specially designed for school use!

Examinations and Prizes
The Joint Committee instituted an annual examination, partly written and partly practical, to take place on two consecutive Saturdays. Sir Philip Magnus helped invigilate and Bannister Fletcher, then Senior Warden of the Worshipful Company of Carpenters was one of the examiners. He and his fellow examiner considered both the paper work and the woodwork "very creditable to the lads, and it speaks well for the teacher's ability to teach, and the earnestness in their work."[15]

Then came the prize giving ceremony for the children from artisan communities and boys and girls (manual instruction included Housewifery, Laundrywork and Domestic Economy) from some of the most deprived parts of London. Distinguished guests awarded the prizes each year in prestigious venues presided over by the Lord Mayor of London.

When it was decided to change the format of the examination and conduct it on a area basis, the Joint Committee noted that children from Barter's centres out-performed those from Pearson's. When the committee asked Pearson to explain the disparity, he said that his pupils came from schools of "special difficulty". Inner city teaching problems are not new! Pearson felt that his pupils had been unjustly treated:

In connection with the work done in the way of constructing "simple objects" etc. It had been a matter of regret that although a very considerable amount of time and attention has been given to the preparation of these *"Objects" of carefully inked work in drawing books, and of "special drawings"* a good number of which were coloured by the boys and mounted — yet no opportunity has been afforded of exhibiting either "objects", "drawing books" or "coloured mounted drawings" before the Joint Committee as a body...Therefore it has resulted that a very large and important section of this year's work has not in any way been assessed by the Committee, nor officially inspected by the examiners, thus precluding any mention in the annual report. The ultimate result being that the whole official estimate of the year's work has been entirely dependent on the exigencies of a short competitive examination, having been the same for two districts of London in which conditions of the children's lives in one, are speaking generally, so advantageous compared with other.[16]

When Pearson resigned Barter was promoted to organiser with overall responsibility for running the Joint Committee's centres. This included the training and appointment of teachers. Barter soon stamped his own imprint on the system he was instrumental in creating. Giving evidence to the Irish Commission on Manual and Practical Instruction he explained:

When we started in London our thought was to have centres in which we should put a teacher in charge of artisan assistants. We recognised the fact that in London the teacher from the time he picked up the tools, was deficient in manual dexterity...We thought if we put our artisan with the teacher that the teacher would improve his personal skill, and the artisan would learn to teach from the teacher, with a view of afterwards promoting our artisan to become a teacher, should he show teaching power and have the necessary educational qualifications. What happened was this — we could not secure enough elementary teachers to take up the work, and we were driven to promote our assistants, who are artisans, to the post of instructor; and in many cases where they have been educated and have been through a good strong course under the Science and Art Department, and were not too old, we have had some splendid work, on the other side, we have had some of our artisans who could not adapt themselves at all to the new condition of things, and they have turned out signal failures. Some of the teachers have proved very successful, and some have proved failures, so I am not prejudiced in favour of either artisan or teacher.[17]

Despite this declaration to the contrary, Barter held dogmatic views which influenced his appointments. All had to attend a training course which he conducted personally and in which he initially gave all the lectures. London teachers were also required to teach to a scheme which he developed and which permitted virtually no individual interpretation. This included the now legendary "tooth-brush rack, soap-box, toilet-tidy, postcard-rack, letter-rack, pen-tray, Oxford picture frame, octagonal and round rulers, dinner-mats, wall brackets, flower- stand, hat-rail, bookslide, dove-tailed box, ink-stand etc."[18] These courses were rigorous and no doubt appreciated by many teachers, but others found his pedagogical style pretentious and restrictive. This partly explains why many teachers who undertook training courses of various kinds failed to seek posts in manual instruction. The word must have got around that Barter really preferred to appoint ex-artisans not teachers and he told the Irish commissioners that:

> I am strongly of the opinion that if you get the real clever artisan and teach him how to teach he makes the best instructor.[19]

Barter certainly developed into a first-rate administrator. However, his determination to produce instructors in his own image estranged him from some of the educational establishment. The Vice-Chairman of the London School Board commented that

> Mr. Nelson (of the Manchester School Board) though he once worked at the bench for 3 or 4 years, is far more of a schoolmaster than a carpenter; whilst Mr. Barter can hardly be called a schoolmaster at all.[20]

John Pearson, now Director of Manual Instruction to the Liverpool School Board, also gave evidence to the Irish Commissioners on the question of trained teachers as against artisans:

> I am entirely in favour of trained teachers because what we do is not to produce the article but to develop the boy, and so we want persons who are really practical at the art of training boys. You may get a skilled artisan. We have one exceedingly striking case who is a very successful teacher; he is successful inspite of being a skilled artisan and not because of it. As a rule the skilled artisan thinks a great deal too much of articles that are being made, and too little of the effect on the boy during the process of making them. I am entirely in favour of trained teachers and trained teachers only.[21]

Thomas Godolphin Rooper, in his evidence to the Irish Commissioners also espoused the employment of teachers:

> I should myself prefer that the teachers should go through some course like that at Leipzig (a specialist teacher training institution), I think if you learn from an artisan you really learn a trade rather than an educational course.[22]

Magnus expressed ambivalent views to the commission. On the one hand he agreed with the chairman that the majority of Solomon Barter's appointments had been ex-tradesmen. On the other he concurred that the best place for training teachers was the training college. He himself summed up these anomolies in *The Practical Teacher:*

In organising a scheme of technical teaching in connection with our elementary schools, the difficulty has to be met of obtaining good teachers and competent instructors. The artisan who is a skilful workman and nothing more, may succeed in teaching the elements of carpentry and joinery; but he is not the kind of teacher needed. It is of the utmost importance that the teacher should be a good draughtsman, should have some knowledge of physical science, should be a fairly expert workman, and should have studied the art of teaching. To obtain at first such ideal instructors would be impossible; but there is no reason why gradually they should not be trained. Two processes suggest themselves. We might take a well-turned elementary teacher, having an aptitude for the mechanical arts, and give him a course of instruction in the use of tools, either in a technical school or in an ordinary workshop. Or we might take an intelligent artisan, who had studied science and drawing in some of the excellent evening classes which are now found in almost every town, and give a short course of lessons in methods in relation to workshop instruction. Good teachers might be obtained by either of these processes. But the former is certainly preferable for the simple reason that instruction should be regarded as part of the general education of the boy, not as part of his apprenticeship. The trained teacher who has received a course of workshop instruction will undoubtedly be better able to make his lessons yield educational discipline than the tradesman who has no pedagogic experience. On the other hand, the expert carpenter would be preferable if the object of the instruction were to teach the boy a trade. The great difference between the two instructors is that the one has a deeper insight into the nature of the children and the other a more thorough acquaintance with the practical details of the work in which they are engaged. Of course, a knowledge of the materials employed and sufficient manipulative skill are absolutely essential for the teacher of woodwork, but no less essential to the teacher of young children is a knowledge of the methods of instruction, founded on some acquaintance with psychology of child-life.[23]

Despite this necessary attempt to placate both camps in his audience, Magnus's later actions furthered the ends of the artisans, not the trained teachers. *The School Guardian* however, argued that:

Trained teachers are essential; it is not enough to *do* the work, the teacher must *explain* how it is done; the artisan may be excellent as an artisan, but most probably has no teaching faculty, has no experience of dealing with children, and is incapable of appreciating difficulties from their point of

view. And the teacher must be educated, otherwise the manual training will be looked upon as inferior to the other school work to the detriment of its true educational value.[24]

City and Guilds examinations

In an attempt to ensure that trained teachers reached an acceptable standard of practical competence, the City and Guilds of London Institute, under the direction of Sir Philip Magnus, introduced a manual training examination specifically for their needs. The first took place in 1892. Candidates had to be teachers employed in public elementary schools and to have made at least twenty attendances at a class of instruction approved by the City and Guilds Institute. The examination continued until 1969, at which time the author was the last examiner in woodwork. During its 78 years thousands of craft teachers took the examinations, either to enhance initial qualifications or as the first step into handicraft teaching. In latter years the number of candidates dwindled as the examination had outlived its usefulness. A typical annual report by the Institute's examiners in 1893 indicates the competence achieved by these early teacher craftsmen.

The practical work of the first year's candidates is, on the whole, very good. Some classes appear to have had no spokeshave, and the candidates used a chisel and file. The final year's work is also good on the whole, though glasspaper in a considerable number of cases was too freely used. In both examinations, sufficient attention was not paid to the printed instructions, and failing to work to exact dimensions given was a general fault.

As regards the Written Examinations, the results show higher general level than last year, the work is more even in character...Two main faults run through the answers. The first is – the knowledge of timbers and tools appears to have been got from books rather than from the things themselves, and consequently there is want of accuracy in the answers of many candidates. For instance, how could candidates who have looked into things firsthand make the cutting angle of the chisel range from 10° to 30°; or describe mahogany veneers as split pieces; or see medullary rays in firs and pines; and distinct sapwood in ash; or find knots in timber are formed by the sap collecting in its course up and down the tree where cracks appear?...The second fault lies in the notes for teaching. Here the candidates for the most part fail to show how they propose to teach, and the notes are little more than descriptions. Even when the method of teaching is taken into consideration, the words "draw from the children" "elicit from the children," occur too often. How is it possible to elicit from the children the names of timbers they have never seen, and the names and special uses of the parts of tools of which they have never heard?[25]

In 1897 the City and Guilds Institute reversed its policy and opened the manual training examinations to artisans, on the grounds that "representations

from artisans" employed as assistant instructors, powerfully supported by the National Association of Manual Training Teachers, could not be ignored. City and Guild's support for the artisans' cause cannot be accepted at face value. The membership of the National Association consisted overwhelmingly of ex-artisans. Moreover, Magnus held the office of President for the first ten years. Add to this the fact that Magnus and Soloman Barter worked together on the Joint Committee and any claim that the Institute acted disingenuously looks distinctly thin. The examinations were soon being taken by better educated artisans who had served apprenticeships in carpentry and joinery or pattern-making and attended evening classes in building construction, geometry and other relevant subjects. Their performance in practical work ranked highly, being described as "on the whole extremely well done"; but in the educational principles of manual instruction they received less favourable comments.[26] The examinations proved popular with artisans and they soon outnumbered the trained teachers. Table 1 gives details of the numbers during the first decade of the examination. Between 1892 and 1896 the number of examination centres increased from 25 to 162, and they continued to grow in the years ahead.

The Guild and School of Handicraft and the Whitechapel Craft School
During the early years of the examination the majority of teachers taking courses came from London and nearby counties. Manchester, Birmingham, Nottingham and Sheffield were the only centres outside the south-east with more than ten candidates in 1892. Llewellyn Smith gave a breakdown of the London figures. These comprised:

1. the training class of the City and Guilds Institute, of about 60 teachers,
2. the centres of manual training of the London School Board (held up-to the end of last year) for about 100 teachers,
3. The Whitechapel Craft School with normal classes for 113 teachers,
4. the Guild and School of Handicraft in the Mile End with about 137 teachers." (1891 figures)[27]

Soon the number of candidates from London began to fall. The City and Guilds attributed this to:

...the smaller classes held at the Guild and School of Handicraft, and the Whitechapel Craft School, where the number of candidates has fallen from 34 and 57 to 17 and 15 respectively. Seeing the large increase in the number of classes in Essex and in other counties bordering on London, it would seem that many candidates who previously attended London classes are now able to receive instruction in Institutions near to their own homes.[28]

It is difficult not to conclude that Barter's preference to appoint artisans rather than trained teachers aggravated the decline. Many teachers who took the City and Guilds examination remained in, or returned to, the classroom.

Table 1 WOODWORK

Year	FIRST YEAR'S EXAMINATION				FINAL EXAMINATION				
	Total no. of candidates	No. of candidates	No. of passes 1st	No. of passes 2nd	Percentage of failures	No. of candidates	No. of passes 1st	No. of passes 2nd	Percentage of failures
1892	615	275	47	108	43.6	340	49	146	42.6
1893	1,141	956	167	508	29.3	185	24	99	33.5
1894	1,766	1,210	284	531	43.8	556	159	237	42.6
1895	1,543	842	309	392	16.7	701	215	389	13.8
1896	1,168	613	209	311	15.2	555	120	261	31.3
1897	946	480	180	219	16.8	466	60	235	36.6
1898	885	531	393		25.9	354	60	157	38.7
1899	782	445	251		43.5	337	71	144	36.2

88

Table 2

SCHOOL	FIRST YEAR'S EXAMINATION				FINAL EXAMINATION			
	No. of Candidates	No. of passes 1st	2nd	Percentage of failures	No. of Candidates	No. of Passes 1st	2nd	Percentage of failures
City & Guilds Inst'n.	24	5	16	12.5	20	5	13	10.0
Fleet Street Classes	7	3	4	00.0	—	—	—	—
Goldsmiths' Institute	6	1	4	16.6	3	—	1	66.6
Guild and School of Handicraft (Essex House)	26	2	16	30.7	8	1	4	37.5
Joint Committees and Teachers' classes	63	16	37	15.8	30	2	17	36.6
Marylebone Technical Sch.	6	—	4	33.3	2	1	—	50.0
People's Palace	8	1	5	25.0	3	—	2	33.3
Whitechapel Craft Sch.	43	5	25	30.2	14	2	8	28.5
	183	33	111	21.3	80	11	15	30.0

Teachers' courses.

The contribution of the Arts and Crafts Movement to the introduction of manual instruction has already been touched on in Chapter 2. Teachers trained at the Whitechapel Craft School and the Guild and School of Handicraft influenced the pattern and direction of manual instruction in elementary schools. Broadly inspired by the writing of Carlyle, William Morris and Ruskin, the Guild had its roots in a small Ruskin class at Toynbee Hall in which three students studied *Fors Clavigera* and the *Crown of Wild Olives* [29] The appeal to East London elementary school teachers of these early socialist thinkers may be measured by the number who flocked to the numerous meetings, lectures and smoking concerts which encompassed a wide range of political, economic, educational and cultural topics. Canon Barnett was able to attract a galaxy of prominent speakers to Toynbee Hall and the garden parties and social functions were attended by the illustrious. The settlement must have provided a heady atmosphere for the first manual training instructors and a stark contrast to the surrounding district. One of the first instructors, Alfred Rose, recalled those years in an article in *Manual Training.*[30] He reported that the teacher craftsmen subsequently took up "many and varied positions in educational handwork." *The Toynbee Hall Record"* outlined the courses attended by 140 teachers.[31] Two of these were started at the wish of a group of schoolmasters and aroused a good deal of jealousy on the part of local trade unionists who feared that their jobs would be jeopardised by cheap, semi-skilled labour. They had nothing to fear.

The issue of "Technical Education and the Trade Unions" was the subject of a debate at Toynbee Hall, where regular talks were given and well attended. William Bousfield, Deputy Chairman of the London School Board spoke at Toynbee Hall of the possibility of technical education in Board Schools. Arthur Acland, MP described in a lecture the aims of the National Association for the Promotion of Technical and Secondary Education as wide ;and in line with the ideals of education reform, and included proposals for teacher training in workshop instruction. His talk was followed by the announcement of the formation of the East London branch of the Association at Toynbee Hall.[32] Delegates attending the 1890 NUT conference were invited to Toynbee Hall and about 150 members accepted.

When the Guild and School of Handicraft moved to new premises in the Mile End Road it maintained its links with Toynbee Hall. At the same time it broadened its approach to educational work and published *The manual of the Guild and School of Handicraft,* [33] designed to publicise to county councils and technical teachers the facilities and courses offered by the Guild. Dr. Roberts suggested the possible formation of a "Technical University Extension Centre at Essex House" at a Conference of artisans and elementary teachers and a motion was passed:

> That in the opinion of this meeting, it is advisable that a University Extension Centre should be established by the Guild and School of Handi-

craft at Essex House and that the School Board for London should be approached with a view to their giving recognition to the University Extension Certificates.[34]

The School Board agreed. Ashbee recognised that the Guild would have to extend its activities beyond the provision of teacher's courses for East End schoolmasters to stay financially viable, and offered holiday courses for teachers living outside of London. *The Schoolmaster* commended the courses to its readers, and they proved very successful.[35] Parallel training courses for elementary school teachers at Whitechapel Craft School were also popular. *The School Board Chronicle* reported that

> There has been such demand for places in the training classes just opened in the Whitechapel Craft School, 27 Little Alie Street, E., that it has been found necessary to start no fewer than six classes, two on Saturday mornings, and on Monday, Tuesday, Wednesday and Friday evenings from 6 to 8. The Friday and Saturday classes are quite full, but there are still a few vacancies on Monday, Tuesday and Wednesday, which may now be filled by teachers from any part of London. Up to the present preference has been given to East London teachers. The fee is 10s. per term for one lesson (two hours) a week, and 17s 6d for two lessons. Application should be made at once to the Hon. Secretary, H. Llewellyn Smith.[36]

The Whitechapel School was soon also offering manual instruction classes for country teachers. A typical letter advertising a course in the educational press informed readers that:

> A course of lessons has been specially designed, so that teachers spending their holidays in the metropolis may, while making the most of their stay in town, become acquainted with the scheme of manual instruction followed here. The course has received the special commendation of many eminent authorities, including Professor Belfield, of the Manual Training School, Chicago, Sir Henry Roscoe, Professor Stuart, and Sir Phillip Magnus.[37]

Walter Degerdon, who ran the courses, was an expert tradesman well regarded by Sir Philip Magnus. He had been woodwork instructor in the Cambridge University engineering workshop and wrote what was described as an "admirable book of practical work on scientific and educational principles."[38] Degerdon also taught carpentry classes at Hounslow Polytechnic for students at Borough Road College.[39] The college erected its own well-equipped carpenter's shop in 1895, and courses continued there until 1972.[40] Borough Road, the principle training institution of the British and Foreign School Society, was pipped by the Methodist Westminster Training College (then in Horseferry Road near the Tate Gallery), the first London College to have its own workshop. One envious correspondent to *The School Guardian* hoped the Church of England would follow suit because "so much attention is now devoted to "technical education".[41]

The introduction of metalwork
Ironically the movement for the introduction of manual instruction that had stemmed from concern about Britain's decline as a manufacturing nation ended with a welter of woodworking. But for the Royal Commission on Technical Instruction metalwork teaching was important in the curriculum and was taught at the William Glen Institute and other institutions which submitted evidence to the Commission. The teaching of metalwork was at least equal to woodwork in French schools, whose facilities had impressed the commissioners. The 1884 report had recommended that:

"proficiency in the use of tools for working in wood and iron".

William Ripper, the Sheffield pioneer, spelt out what this meant in practice:

A good school workshop system should include: 1.) A woodworking department, fitted with benches, and supplied with the more ordinary wood-working tools, and a few wood-turning lathes. 2.) Metal-working department, containing benches, fitted with vices and supplied with hammers, chisels and files. One or more small iron-turning lathes and a small drilling machine. A few smith's hearths and anvils.[42]

Both Professor Ripper and the commissioners were to be disappointed. Though A.W. Bevis, manual instruction organiser for the Birmingham School Board, recorded that schools in districts where engineering predominated now had metalwork shops[43] and James Runciman declared in *The Contemporary Review* that:

Sheffield lads work admirably in iron, and Birmingham boys seem ready to turn their hands to almost anything.[44]

In reality the provision for metalwork instruction was at best patchy and in places non-existent, partly because certain of the manual instruction camp opposed *sloyd* as being a foreign educational movement making models in wood alien to British schoolboys. Miss Hughes, the Cambridge Training College Principal, defended the *sloyd* position at the annual meeting of the Sloyd Association:

Fortunately for *sloyders* the originator of *sloyd* is a philosopher as well as a very practical man; and he has never made the mistake of confusing the universal and the local. He has protested over and over again that some of the Swedish models are absurd, and militate against the theory of *sloyd* when used out of Sweden. I remember once he reproved me stoutly for lecturing on wood *sloyd* in Sheffield. 'You should have adapted yourself' he said, 'to local conditions. You should not have talked about wood *sloyd* where half the population are concerned with metal work. The schoolboys of Sheffield must have inherited skill in metal work; every day of their lives they probably see and hear something of such work. You should have confined yourself to metal *sloyd*[45]

Salomon's words went largely unheeded by his opponents — and, indeed, by most *sloydists*. The City and Guilds Institute claimed to have received "numerous applications" to provide a manual training examination in metalwork corresponding with the woodwork examination, but there were only 54 candidates for 1894. By 1903 it had reached 125 but woodwork attracted 339.[46]

In London, metalwork did not form part of the original Joint Committee scheme but metalwork was taught at Canon Barker's Church of England Technical School at Marleybone. When the Joint Committee decided eventually to introduce metalwork it leased the premises from Canon Barker.[47] One reason that metalwork shops were developed later than woodwork was because it was widely believed that young pupils should first work in a less resilient material. Even today this approach is not without its supporters. Once the Joint Committee had decided to introduce metalwork, it went about it with characteristic thoroughness. It requested details of their courses from the School Boards of Sheffield, Birmingham, Liverpool and Manchester, the City and Guilds of London Technical Institute for the Advancement of Technical Education, the United Westminster Schools, L'Ecole Municpale Diderot, Paris, Chemnitz, L'Ecole Professionelle (Rheims), Allen Glen's School, the German Union for Manual Training, Leipsig, The Polytechnic, Regent Street and Canon Barker's Metal-working school.[48] After all these, the Joint Committee asked Barter to prepare a metalwork syllabus. Barter proposed that boys of thirteen — then the school leaving age — should spend one and a half to three days on the theoretical and practical aspects of the new work and hoped that the instruction would be "beneficial" and "help the boys to discovery of occupations suited for them, and of smoothing their path in their chosen callings". He presented the syllabus "largely as a bridge between Manual Training and the teaching of trades," true to the spirit of the Royal Commission.

In towns outside London, however, metalwork was only taught in central and special curriculum schools, linked often with schemes for an extension of science teaching. The cost of equipping metalwork shops was a major deterrent to further provision. School boards preferred to spend the rates on woodwork as it was cheaper. In 1898 when the Department of Science and Art merged with the Education Department, 66,668 pupils in 808 English elementary schools were examined in manual instruction[49] (The comparable figure for drawing was 1,161,342 pupils in 10,180 schools). By 1910 the number of pupils eligible for a grant in manual instruction had increased to 187,111 taught in 4,264 schools.[50] The balance continued to be strongly in favour of woodwork. Even in 1952 the Ministry of Education Published *Pamphlet No. 22* (re-issued 1959) advising on how metalwork should be taught and commented unfavourably on the metalwork centres still in existence.[51] Metalwork did not apparently approach parity with woodwork teaching for another decade.

Teacher training – the key to sustained progress

Failure to resolve the problem of teacher supply shattered the hopes of the original sponsors of manual instruction, jeopardised the success of subsequent developments and threatens to freeze the outcome of current initiatives should the present favourable conditions cease. It is futile to embark on a policy which totally disregards the legacies of previous strategies. Although the Board of Education in 1910 (in a report which used the term 'Handicraft' for the first time) dismissed as one of "certain anomalies", the employment of skilled craftsmen, the schools were stuck with them. Even their presence was perceived as impeding progress, supplementing the ranks of ex-artisans with teachers who failed their examinations, the Board had to accept the certificates of the City and Guilds of London Institute.[52] This depressed the already low standard of general education among handicraft teachers, alarming the National Union of Teachers.[53] Some critics argued that teachers of practical work should hold qualifications of a standard required for other subjects. These critics argued that the often limited educational background of many artisans would prevent their teaching their subject according to the general principles of education.

Shoreditch College – early days

Only a small number of training colleges – principally Chester, Westminster and Borough Road – established proper courses. The piecemeal training and supply of suitably qualified teachers continued to be a dilemma. To counteract this state of affairs in its own schools the School Board for London responded by instituting four in 1894, and later ten, manual training pupil teacherships, for suitably promising boys to receive a form of apprenticeship. After an encouraging start, this pioneering venture became fragmented and directionless. Andrew Rowan a young Scottish teacher, with the support of Dr. Kimmins, the LCC inspector and Dr. Garnett, the Council's Education Adviser, determined on a new course more "worthy of the name and dignity of the LCC"[54] and the London County Council duly recommended:

> That as from August 1907 and until further notice pupil teachers of manual training do receive instruction at the LCC Shoreditch Technical Institute.[55]

Shoreditch College of Education was born. From humble beginnings in the centre of London's East End furniture industry, the Manual Training Department prospered. After a thorough inspection, an impressed Board of Education recommended that:

> 'a full training college course be provided in the immediate future carrying with it the Board's full certificate qualification.'

The war intervened, but the new training college opened in nearby Pitfield Street, where it remained until 1951. From the outset Andrew Rowan based the course on liberal studies. He viewed his students with a degree of technical

expertise, as leading the training of the next generation of handicraft teachers. From the thirties to the early fifties the course had uniquely a two – plus – two structure: two years in the Preparatory Department followed by two years leading to the Teacher's Certificate qualification. In 1930 Shoreditch College became a member of the Training Colleges Delegacy of the University of London, enhancing the rigour of its academic studies.

As demand grew for professionally trained handicraft teachers, a number of denominational and local authority colleges in the country added handicraft (mostly woodwork) to the subjects for the Teacher's Certificate. At Loughborough College, the Teacher Training Department, which grew out of the highly reputable engineering course, soon developed an exceptionally fine furniture department. Through Peter Waals, a supreme craftsman in wood, and Edward Barnsley, Loughborough College could boast a direct lineage from William Morris and the Arts and Crafts Movement.

Despite increased provision in training colleges demand still outstripped supply. According to one report

the number of teachers qualified to take craft in senior schools is at present, in spite of growing interest in the subject, and the stimulating work of local and central guilds and associations, insufficient.[56]

It remained impossible to do without men recruited from industry. They still qualified mainly by taking City and Guilds certificates and this pattern continued till after 1945.

The Crisis in teacher supply

An inter-war problem of teacher supply developed into a post-war crisis. The depleted ranks of craft teachers consisted initially of men too old for active service and ex-servicemen trained in the inter-war years. New blood entered the profession through one of the intensive emergency training college courses, coming either straight from national service or from industry, generally via the old City and Guilds examinations. The aftermath of war, combined with the reorganisation of the secondary school system and the raising of the school leaving age from 14 to 15 resulted in a sharp rise in the demand for craft teachers. Gradually this subsided but after a few years of near equilibrium in the 50s the post-war "bulge" reached the secondary schools. At the same time the school leaving age was raised again. These two factors created unprecedented increases in the demand for craft teachers. It was met by an expansion of existing courses, the creation of new departments and an increase in the number of entrants from industry.

The colleges which changed from a two to a three year Certificate of Education structure in 1962 could not – even with perilously low entrance requirements – keep pace with demand. Between them, Loughborough and Shoreditch College (which moved from the East End to the Thames Valley at Runnymede in 1951) trained about one-third of the country's handicraft teachers in the mid-60s.[57] Most other college craft departments also expanded, some

spawned new ones and a number developed into wing colleges. The increased number of initial teacher training places provided in the confident sixties were a problem to fill in the seventies. Shoreditch College partially disguised its own local difficulty by introducing a general course in 1970. The number of applications had been falling for some time. Elsewhere the collapse of recruiting had devastating consequences. By 1980 only 50 − 60% of initial teacher training places were taken up nationally. In 1977, as teacher training wound down the ILEA decided to close Shoreditch College, to the surprise and embarrassment of the D.E.S. Numbers had fallen from their 1960s peak of over 200 per year but the college still produced about one-quarter of the country's CDT teachers. The ILEA argued that it could no longer be responsible for funding and staffing a national college now that it had been compelled to reduce drastically its number of initial teacher training places. It proposed to satisfy London's needs by transferring fifty Shoreditch places to another ILEA college, Avery Hill, which had been unsure of its own future. The ILEA apparently thought that closing Shoreditch would cause less of an outcry, but in this they were mistaken.

The fight to save Shoreditch College began, brilliantly led by Chris Slater, a senior lecturer in the English Department. One vital spin-off was that it heightened the general awareness of the shortage of specialist CDT teachers. Those working in the subject were well aware of the shortage and it was apparent to individual schools whenever they advertised posts that applicants were thin on the ground. Advisers,inspectors and headteachers expressed feelings of unease but stopped short of concerted action. Compare the situation in mathematics and physics, where, well organised pressure groups of subject specialists and interested parties existed. They ensured that the shortage in these areas received regular and sympathetic airings in the educational press and media. Questions were prepared to be asked in Parliament: naturally, the prestigious nature of these subjects helped.

The Shoreditch College Publicity and Recruitment Committee

Concern over the alarming shortage of CDT teachers, allied with the almost total lack of accurate information of the reasons for this perplexing state of affairs, prompted the author and Margery Smalley to undertake a survey, mentioned in the last chapter, of some 450 secondary schools in England and Wales during the academic year 1976-1977. Our findings drew attention to several factors which appeared to be partly responsible for the inadequate number of teachers. It also provided an insight into what was really happening in CDT departments. Within a year, what began as an academic study became inseparable from the College's fight to survive. The author became chairman of the Publicity and Recruitment Committee; Margery Smalley, the conference organiser. Initially, the Shoreditch campaign relied heavily on the loyalty of over a thousand ex-students. This parochial episode was short-lived. Soon the College joined with representatives from other colleges and LEAs from all over the country to try to get across to sixth-formers information on the

shortage. It also enjoyed a particularly fruitful relationship with the Equal Opportunities Commission, which from this time wholeheartedly took up the issue of 'girls into CDT'.

The committee developed a two-pronged strategy. On the one hand it aimed at widening the awareness of the shortage in general and, on the other, at informing school audiences in particular of the career opportunities in teaching CDT. Sixth form conferences were held in many parts of the country. The first, at Shoreditch College in 1977, halted the committee in its tracks. Conference planning had been based on the assumption that the majority of the young delegates — especially those taking CDT 'O' level — were aware of the CDT teacher shortage. Not so. Responses to a questionnaire revealed that most sixth formers were of the impression that the profession suffered from a surfeit of teachers. Against a background of drastic college of education cuts, no one was taking the responsibility to tell sixth formers about the CDT shortage.[58] The message had to be hammered home: career opportunities in the subject were good. Few new entrants into CDT teaching stayed for long on the bottom scale.

In one respect the Shoreditch campaign was unique. A number of regions were targeted, notably the North-East, where job prospects were bleak and the pool of untapped ability high. Carefully prepared recruitment weeks took place with the active support and encouragement of CDT and career advisers in Newcastle, Cleveland, Northumberland, South Tyneside and Durham. Several members of the Shoreditch staff, along with a group of students, most of whom came from the locality, visited in turn a number of strategically situated centres. Nurturing the media played a vital role in these local campaigns. Journalists responded by producing well-written articles and photographs for local newspapers, radio interviews were given and live appearances made at peak viewing times on Tyne-Tees Television. The strategy produced results. At a time of plummeting recruitment figures nationally (they could have been even worse but for the Shoreditch campaign), the Shoreditch total stood out as the exception. At every conference teachers and their students completed a questionnaire. These provided invaluable data subsequently written up to reach a wider readership.[59]

In addition to its main task of encouraging recruitment of CDT teaching, contacts with so many schools across the country afforded the Shoreditch committee an ideal opportunity to quantify the seriousness of the national CDT shortage. Its own estimates revealed a wide discrepancy between them and the official figures based on LEA returns — then reporting a shortage of less than 300. This could be proved a gross under-estimate. In 1978 alone the 'jobs' notice board at Shoreditch College carried over 500 letters and advertisements from schools for Scale 1 posts. Many heads, despondent of ever filling vacant posts, thought letter writing a futile waste of time and never bothered to contact the college. To this total must be added the columns of advertisements in the *TES* and *The Guardian* both for probationary and more senior teachers. To complete a dispiriting picture, the committee also received regular reports

of workshops being closed or put to alternative use because of the unavailability of CDT staff. Confirmation of the severity of the shortage came in a Parliamentary reply. Gordon Oakes, Labour Minister of State for Education and Science, who visited Shoreditch College asked Rhodes Boyson:

What is the estimate of the present shortage of teachers of craft and design in primary and secondary schools?

Dr. Boyson informed Oakes in a written reply:

In January 1979, the local education authorities in England and Wales reported 294 vacancies for teachers of craft, design and technology. However, preliminary analysis of data from the Department's 1977 secondary school staffing survey indicates that the real shortage could be in excess of 2000 teachers.[60]

Is to relate this minor episode in the history of CDT anything more than an indulgence on the part of the author because of his personal involvement? Objectively the importance of the Shoreditch campaign rests on the fact that for three years it checked temporarily the vicious downward spiral of falling recruitment to initial teacher training institutions. The circumstances were far from favourable. It needs to be emphasised that at the time Shoreditch College had no assured future, a situation aggravated by the Certificate in Education being phased out and the B.Ed. being introduced. The impact of the requirement for all applicants to have at least two 'A' levels is easily underestimated. For a subject that traditionally recruited a significant proportion of its applicants on the basis of passes at 'O' level, this required a major readjustment on the part of all colleges and feeder schools sending aspiring applicants.

It can only be a matter of conjecture, if time and resources had permitted, what might have been attained – for the Shoreditch work described was undertaken by staff and students with full teaching loads and only occasional relief. There is every reason to believe that if the expertise and drive of the Shoreditch team had been strengthened and augmented, the situation we find ourselves in today might have been averted. Mark Carlisle, then Secretary of State for Education, commended its work when he opened the conference 'Opportunities for Women in Teaching Craft, Design and Technology' at Shoreditch College in December 1979:

...despite the potential of CDT as a subject to teach, recruitment to it is difficult and there is an acute shortage of teachers. I am sure there are a great many reasons for this – one of the most important is the historical fact that, until fairly recently, very few of the most able pupils, and also very few girls, developed a strong enough background in the subject at school to be either interested in or equipped for training as a teacher. Now perhaps,...a solution to this problem will be found. But this will not happen without a good deal of recruitment effort. The Department is doing its best on this...But there is no substitute for active recruitment

efforts by the training institutions themselves. And here Shoreditch has admirably shown the way.[61]

Changing recruitment patterns

All this is so much water under the bridge. The work of the Shoreditch Committee came to an abrupt end. Nothing has replaced it. We are back to a situation in which everyone expresses concern over recruitment but it is someone else's problem to do something about it. Lamely the Crafts Council in 1979 projected that falling student numbers would continue to plague teacher training institutions. In the circumstances its recommendation that "An attempt should be made to increase the number of non- specialist students taking selected craft courses" hardly carried the necessary clout.[62] Similarly, the Standing Conference on Schools' Science and Technology set up a committee chaired by Harry Knutton, then Director General of the City and Guilds of London Institute. Its widely publicised report, whilst more concerned with the shortage of mathematics and science teachers, acknowledged the seriousness of the shortage of CDT teachers.[63]

Whether it produced a single extra CDT applicant is doubtful. Among CDT teachers many cherished a pious hope that the remedy rested with the inspectorate. As Mark Carlisle cautioned, the power of the DES is limited to setting the scene and providing the political framework within which individual initiatives can prosper. George Hicks, staff inspector for CDT, like his predecessor John Swain, has taken this line. He has frequently urged that all those involved in CDT teaching should take an active part in recruiting suitable applicants. Typically, when he addressed members of the Educational Institute of Design, Craft and Technology not to slacken their endeavours on this count, he advised:

If our subject is to enjoy the future it has built for itself, two things are necessary: Firstly — a greater supply of students for teacher training. Secondly — a heightened sense of professionalism amongst all practising CDT teachers. Possibly the two are inseparable for if we tackle the second one first we might solve the first without realising it.[64]

This is an appropriate moment to pause and reflect on the magnitude of the changes to which initial teacher training institutions have been subjected in little over a decade. Ten years ago there were over 30 colleges of education with CDT departments. Today the figure is down to 20. Within this reduced total a number have been affected by mergers of various kinds. Bureaucratic decisions to reduce the number of teacher training places overall failed to take into account the delicately balanced nature of CDT provision which, once disturbed, had momentous consequences for recruitment. When Shoreditch and Loughborough dominated the supply of the country's CDT teachers, both colleges relied overwhelmingly on the recommendations of past students to fill the bulk of their places. A closer look at the Shoreditch figures however reveals that a surprisingly small number of schools actually had a tradition of

sending students to the college on a regular basis. Probably less than 200. Amongst this group some would have as many as 10 former pupils studying at the college at any one time. The seriousness of the criticism that the field became very inbred was not without substance. Nevertheless, places were filled and not all the resultant offspring turned out to be monsters!

Now that traditional loyalties have weakened, CDT recruitment is foundering. Everywhere teacher education institutions have faced periods of indecision. De La Salle College in Manchester and the College of St. Mark and St. John in Plymouth both suffered; H.M. Inspectorate was promoting expansion at the very time that bureaucrats were proposing to axe their courses! Before the B.Ed. was instituted, handicraft teachers took a route into the profession similar to primary teachers,whereas most secondary school teachers came into teaching via post-graduate courses. Students in colleges of education had pursued courses in which subject matter and professional content were generally linked – intentionally so. But the coming of the B.Ed. degree required that subject matter be separated from professional content and education.

When Loughborough and Shoreditch College entered the university sector, both adopted a modified version of the concurrent pattern of teacher education as the basis for their new undergraduate courses. This created a new problem: the pattern is often regarded as incompatible with the normal university post-graduate provision for intending teachers. – though at the time it was believed that university status for CDT would solve it! Both universities were also plagued with a recruitment problem. Perceptions of course content among potential applicants and their teachers had changed and the diversification of opportunities open to bright sixth formers who might previously have opted for teaching did not help matters. Nor has the hammering of the teaching profession from the Government and the media.

Is this to over-state the inter-related problem of recruitment and CDT vacancies? Today the situation looks rather less serious than in the 1970s, when there were around 2000 vacancies. Since 1984 it is less than 200 according to DES statistics. [65] Job vacancies on the Brunel noticeboard numbered about 75 in June 1987. On the recruitment front some departments are fuller than they have been for years but this has been achieved mainly at the expense of Loughborough and Brunel university. Students with a craft and design background who in former years might have been accepted by either university now have to look elsewhere. The improvement is due largely to a combination of falling school rolls, school mergers and the retraining/conversion course programme.

Retraining courses
It is ludicrous that the present retraining courses should have achieved such prominence when the demand and expectations for CDT had been so high. When the DES first designated ten centres to run such courses, they were seen merely as a temporary measure. When Gordon Oakes asked Rhodes Boyson

how he proposed to relieve the shortage of CDT teachers, the Minister replied that:

> The Department is currently examining ways in which the shortage might be overcome. As an interim measure, the Government's special one year courses to retrain teachers, or to train other appropriately qualified people, to teach these subjects are continuing in this academic year and have been approved for a further year, with financial support from the MSC.[66]

He did not say that the DES was also under pressure from teachers' unions which were intent upon avoiding future redundancies. The unions have succeeded: several thousand teachers who have undergone retraining courses in physics, mathematics and CDT are now redeployed in new areas, thereby staving off the prospect of unemployment in the profession. CDT teachers had strong reservations about the advisability of the conversion course programme at the time. Accusations of "dilution" were rampant, yet, surprisingly, course evaluations at the end of the first year pronounced them a success. To whom had the DES been listening? Not to disinterested objective advisers, but to the departments running the courses. Student recruitment in some of these had fallen so low that a number of lecturing posts looked like folding without a retraining intake. If the DES had listened to the women at the conference 'Opportunities for Women in teaching Craft, Design and Technology' reported in Chapter 2, the Department might have come to a very different conclusion.

So far as CDT is concerned, the courses may have given a second wind to some 'over-the-hill' P.E. teachers (probably the largest single group) and opened doors for teachers of other subjects whose job or promotion prospects looked dim. They stand now in front of classes in workshops that otherwise might have closed — but how effective are they as teachers? With their backgrounds and the time available for the retraining programme, it is impossible to equip them with more than a survival kit for everyday CDT teaching. Of necessity, most time has to be spent imparting the skills needed to cope with 3D on a wet Friday afternoon. For the foreseeable future, this still means learning how to perform a range of processes in wood, metal and plastics and to communicate graphically, skills that are not achieved overnight. An eight month course is too short. To give teachers a chance, in-service provision needs to be at least of the length and intensity of the emergency college courses of the post-war era.

Special entry routes into the profession have created a problem for the teaching of workshop subjects. Throughout the '60s and '70s at least one-third of teachers came from industry, as had been the pattern since the beginning of the century. Their numbers were regularly topped up by fresh entrants with appropriate technological qualifications. To this group must now be added teachers from retraining courses. This method of entry is quicker and allows greater flexibility than a degree course. From 1979 to 1981, almost sixty per cent of teachers entering CDT came via one-year courses,[67] and one year

course entrants continue to outstrip what should be the primary and normal method of entry. If the present trend continues they will outnumber the 'professionals'.

Teachers of Technology

If the situation elsewhere were more encouraging, all this would be less worrying. Nor is it a new problem. The Schools Council Project Technology Pilot Report in 1967 stated that:

> ...the flow of teachers from colleges of education who have followed courses with a special emphasis on applied science and technology is negligible.[68]

Fifteen years later HMI Michael Ives, using data supplied by teacher education institutions, informed an audience of CDT lecturers:

> only five colleges included technology of any significance in their initial training course. Seven others include minor topics of technological nature. For the rest, that is half the survey, there was either specifically none or none that was detected.[69]

To blame the colleges for the ills of the profession is a knee-jerk reaction shared by most teachers, but this is unfair. True, the colleges were not providing sufficiently technological courses. The criticism was unfair because their staffing and resources were so limited that they were simply not capable of developing this aspect of CDT.

Most college CDT departments are a microcosm of the profession, made up mainly of teachers who started their careers in woodwork, metalwork and technical drawing. Commonly, if lecturers topped up their first qualifications, they took diplomas and degrees in education. Only rarely did they go for qualifications in technology or engineering. In the late '60s and '70s when the tide flowed strongly in a design direction, departments strengthened their teaching by appointing lecturers with an art and design background. Latterly this is happening in technology, but much lee-way remains to be made up. So departments naturally fight shy of teaching technology. If B.Ed. technology is not to carry a 'Mickey Mouse' label, those who teach it must be appropriately qualified: a first degree in engineering or technology at least.

It is imperative that CDT − especially the technological element − is rigorously taught. As the next chapter relates, this is a cause of mounting tension between the scientists and CDT. Scientists are adamant that the basis of technology must be mathematics and physics. Handel Davies, who chaired the Standing Conference on School Science and Technology stressed this at a conference on 'The Contribution of Education to Economic Recovery:'

> CDT is not of value if it involves any sort of abandonment of the fundamentals of science and mathematics. That is the general attitude in industry and it has to be looked at very carefully.[70]

Few of today's 14,000 or so CDT teachers, like the teacher trainers, are well qualified engineers or technologists. How then is CDT to adjust to the new requirements when most of the teachers have a craft background? This is not even always seen to be a problem. Put another technology bus on the road, or provide more INSET (mainly brief) courses and teachers will soon get the "knowhow". To date about 7000 CDT teachers have attended such courses. It is often difficult for teachers to be released from the classroom with an average INSET grant per teacher of less than £100 per annum. Nor have many teachers metamorphosed into competent teachers of technology as the result of such in-service training. Most will simply have acquired a life-line to enable them to cope at a minimum level. In a subject so vast and constantly changing as technology it is unrealistic to assume that the required knowledge is easily gained. How often will teachers have the chance to up-date their knowledge? A notion that technology is an extension of, or superior form, of metalwork may be a useful confidence-building exercise but it is open to misinterpretation. No one disputes the energy and zeal behind the fleets of technology buses but is it really possible, as a spokesperson for the British Schools Technology trailer project claimed, to acquire in a four week course

...sufficient knowledge and expertise to teach structures, mechanism, instrumentation, pneumatics and electronic systems to CSE, 'O' and 'A' level or the new 16 plus technology exam?[71]

Yet teachers, reinvigorated by INSET courses, do indeed return to their schools and teach technology to examination level. Does this, however, say more about the rigour of the examinations than the industriousness and enthusiasm of the teachers? There is a traditional saying that one-third of teachers went on courses to get away from their wives, one-third because they were sent and one-third to learn! There is also the fear that promotion will elude those who stay behind in their workshops. However, most teachers attend in-service courses in order to cope with the changing examination pattern.

Teachers need to be able to whet the appetite for technology and to teach it rigorously within its scientific and mathematical framework. At present many teachers admit that they rely on the all-pervading modular technology textbooks, supplemented by INSET handouts and teaching packs. It smacks of the workshop equivalent of rote learning — the technological equivalent of painting by numbers. It may lead to an increase in examination entries, but at a price. Sir Barnes Wallis warned that:

After forty years' practice as a Scientist, I am convinced that any attempt to specialise or teach technology in the most formative years of a boy's life is wrong.[72]

This not quite the rejection it may appear: his criticism is directed at sterile teaching regimes which endangered creativity instead of encouraging it. He

believed that to be an effective designer required a thorough knowledge of materials and their working qualities. Barnes Wallis had been taught by science teacher, Chas. E. Browne in the creative environment of the Science School at Christ's Hospital. Browne, committed to the heuristic method of science-teaching developed by Henry Armstrong, took the view:

> If the boys are to be taught anything, it will be in the spirit of curiosity and this they will acquire not by formal lessons but by practical effort, not in the conventional classroom but at a work bench.[73]

The gulf between the education Barnes Wallis received in the Science School at Christ's Hospital and schools today may appear unbridgeable. Yet it is not so very different in spirit from that in which technology is being taught in an increasing number of independent and innovative state schools. Needless to say it has nothing in common with teaching the mechanical, predictable exercises which may go under the name of technology.

Recruitment – an uncertain future

The deterioration,over many years, of the traditional recruitment channels into CDT is currently provoking urgent initiatives to attract applicants from new sources and renewed efforts, ironically, to up the numbers coming from industry. For most of its history, workshop teaching depended on this route for about one-third of its teaching force, but instead of welcoming this touch of realism, there has always been tension between college trained teachers and those with an industrial background. In the early days, reluctance to appoint ex-tradesmen stemmed from anxiety about status and professionalism. No one disputed that the first artisan teachers knew their subject, but at a time when manual instruction was struggling for recognition, they were often regarded as a drag on the subject. The transition from industry to teaching was difficult and some did not succeed in their new profession – but then, not all college trained teachers are paragons of the pedagogic art. Many CDT departments include teachers who started their careers in industry or in the technical branches of the armed services and the best of these enriched the profession. The problem has always been, and will be in the future, one of integration and balance.

Now, of course, the teaching profession can no longer seek recruits among the ranks of ex-tradesmen with City and Guild certificates. Since the '60s, potential applicants must possess a Full Technological Certificate (FTC), Higher National and a variety of graduate or post-graduate qualifications. At present proposals are being put forward to encourage entrants without graduate status (including those with B.Tech.) to take a B.Ed. degree from an attractive entry point. How bizzare it is, that most of those teachers who came into teaching because of disenchantment with industry or the prospect of redundancy, will now be expected to slant their teaching to meet the needs of industry!

Teacher recruitement for CDT is in a state of confusion. Despite new initiatives, attracting sufficient teachers with the flair and commitment to bring

technology alive and realise its full potential for education appears unlikely. Salary negotiations and conditions aggravated an already tense situation and diminishing social esteem plus the piling of the evils of society at the profession's door has brought previously marginal factors to the fore. At the top end of the salary scale, teachers in their mid-fifties and over are taking early retirement. They have had enough. The loss to state education of these highly experienced teachers is hardly noticed in the escalating acrimony. The flight of younger teachers, many with technologically marketable skills, is more worrying still.[74] Moreover, an increasing number of students, dismayed by the uncertain prospects and low status the profession offers, now seek careers elsewhere at the end of their course or their probationary year. And many were the best of the students. Potential applicants for CDT teacher training courses that have a background of mathematics, physics and − one would hope − CDT are the students in greatest demand elsewhere. To make matters worse it is projected that the number of candidates taking 'A' levels in these subjects is likely to fall. We do not know how many students currently on CDT teacher education courses have qualifications that really equip them to teach technology effectively, but it is unlikely to be many. Most of today's students are limited in their choice of subjects by decisions they made in their third year of secondary education. Five years ago the ability to teach technology was not a priority for prospective CDT teachers. Nor is there much likelihood that today's third year pupils are being encouraged to think in terms of technology teaching, whereas in the seventies attempts were made to "catch 'em young". A study at Bath University highlighted the importance of children being advised to take appropriate subjects if they wished to pursue a technological career and suggested that:

> ...perhaps all schools should start careers lessons in the third year. Case study schools, selected because their pupils had unusually favourable attitudes to technology and industry, were usually exceptional in the emphasis they placed in the third year on consultation over option choices for the fourth year, or provided career lessons in the third year.[75]

Research at Oxford University reinforced the crucial nature of subject choice.[76] Both studies investigated the factors which undermine take-up of technology by fourth formers.

CDT teaching may look in better shape than ever, but at an educated guess, about 75% of schools are primarily equipped for teaching woodwork and metalwork, albeit with strong design orientation and a growing emphasis on technology. The changes of recent years have been brought about by various factors. High on the list must be the commitment of many teachers to an emerging CDT philosophy, and their willingness to work hard keeps the subject flourishing. But for how long? The career of one teacher, who came to Shoreditch from an ILEA comprehensive school with 'A' levels in mathematics, physics and design and technology is illuminating. When we met two years ago, he was teaching in a mixed comprehensive school of 1500 pupils, all of

whom took CDT for the first three years. The school had recently changed to the Cambridge 'A' level technology paper and he spent countless hours outside timetabled time supervising examination project work. After ten years in the profession he had been promoted to a head of department at scale three. He was reading for an MA at the University of London Institute of Education in his own time. He enjoyed his work but has left teaching to become an LEA adviser. At our meeting he had said: "My sixth formers see how hard I work and there's no way they can be encouraged to do what I do for the money they know I earn." Who will make up the next generation of CDT teachers?

References

1. School Board for London *Minutes of the Joint Committee on Manual Training* (October 1998 – May 1900).

2. *Ibid.*, (8 November 1887).

3. "An Artisan" *St. James Gazette* (6 December 1887) 3 This and subsequent letters were printed in *The School Guardian* 12 (December. 1887).

4. *Ibid.*, (12 December 1887), 13.

5. *Ibid.*, (14 December 1887), 5.

6. *Ibid.*, (16 December 1887), 5.

7. Irish Commission on Manual and Practical Instruction *Minutes of Evidence* (1898), 74.

8. School Board for London *Minutes of the Joint Committee* (6 February 1893).

9. *Ibid.*, (29 July 1889); 8 May 1888); (9 October 1888).

10. *Ibid.*, (8 May 1888).

11. *Ibid.*, (17 July 1889).

12. *Ibid.*, (May 1888).

13. *Ibid.*, (12 July 1889).

14. *Ibid.*, (29 July 1889).

15. School Board for London *Report of the Joint Committee on Manual Training* (1893), 37.

16. School Board for London *Minutes of the Joint Committee* (3 February 1890).

17. Irish Commission of Manual and Practical Instruction *Minutes of Evidence* (1898), 72.

18. *The Schoolmaster* 40 (312 October 1891), 711.

19. Irish Commission on Manual and Practical Instruction *Minutes of Evidence* (1889), 76.

20. *Journal of Education* 14 (November 1892), 580.

21. Irish Commission on Manual and Practical Instruction *Minutes of Evidence* (1898), 188.

22. *Ibid.*, 81.

23. *The Practical Teacher* 8 (June 1888), 171.

24. *The School Guardian* 17 (25 June 1892, 457.

25. City and Guilds of London Institute *Extracts from the Examiners' Report* (1895).

26. *Ibid.*, (1899), 24.

27. H. Llewellyn Smith *Report to the Special Committee on Technical Education* (1892) London County Council.

28. City and Guilds of London Institute *Extracts from the Examiners' Report* (1893).

29. C.R. Ashbee *A Short History of the Guild and School of Handicraft* (1890).

30. A.G.G. Rose 'A Forgotten Pioneer' *Manual Training* 12 (August, 1913), 211.

31. *The Toynbee hall Record* No. 2. (November 1888), 8.

32. *Ibid.*, No.7 (April 1889), 80.

33. C.R. Ashbee (ED) *The Manual of the Guild and School of Handicraft: A Guide to the County Councils and Technical Teachers* Cassell (1892) See *The School Board Chronicle* 48 (16 July 1892), 69; *The Schoolmaster* 42 6 August 1892), 194; *The Journal of Education* 14 1 October 1892, 553.

34. School Board for London *Minutes of the School Board for London* (19 November 1891), 1498.

35. 'Country teachers and Manual Training at the Guild and School of Handicraft' *The Schoolmaster* 41 (9 April 1892).

36. The School Board Chronicle 45 (24 January 1891), 91.

37. *Ibid.*, 48 (23 July 1892), 88.

38. W.E. Degerdon *A Graduated System of Manual Training for Elementary and Technical Schools for the pupils of the Whitechapel Craft School* 1892).

39. *The Educational Record of the British and Foreign Schools Society* 13 (October 1893), 350.

40. G.F. Bartle *A history of Borough Road College* (1976) Borough Road College.

41. 'Workshops for Training Colleges' *The School Guardian* 17 20 August 1892, 605.

42. Report 'Professor Ripper on Technical Education' *The Schoolmaster* 30 (27 November 1886), 768.

43. Irish Commission on Manual and Practical Instruction *Minutes of Evidence* (1898), 9.

44. J. Runciman 'The New Departures in Education' *The Contemporary Review* 54 (July 1888), 50-51.

45. *The School Board Chronicle* 51 17 February 1894), 181.

46. City and Guilds of London Institute *Department of Technology Report* (1903).

47. School Board for London *Minutes of the Joint Committee* (4 April 1892), 176.

48. *Ibid.*, (4 April 1892), 178.

49. Department of Science and Art *Supplement to Forty-Sixth Report* (1898), 468.

50. Board of Education *Report of Board of Education* (1911-12) 37.

51. Ministry of Education Pamphlet No. 22 *Metalwork in Secondary Schools* (1952).

52. Board of Education Circular 1251 *Recognition of Teachers of Handicraft* 1922).

53. See LGE Jones *Training of Teachers in England and Wales* (1924), 170. Oxford University Press.

54. F.H. Giles *Mr. Andrew Rowan: his Early Work and Achievements* 1970). (Privately printed) Narbulla Agency Press.

55. London County Council *Minutes of the Higher Education Sub- Committee* (24 July 1907).

56. London County Council *Handicraft in Senior Boys' Schools* (1933), 3.

57. J.B. Penfold and M.A. Smalley, 'A Touch of Class — Shoreditch Style', Brunel Bulletin (June 1980), 10.

58. J.B. Penfold and M.A. Smalley, Letters: 'Communication breakdown over Design' *The Times Educatyional Supplement* (November 1977).

59. J.B. Penfold and M.A. Smalley 'A Bridge to Brunel' ILEA *Contact* (25 November 1977).
J.B. Penfold and M.A. Smalley 'Design Technology Shortage' *Times Educational Supplement* (24 August 1978).
J.B. Penfold 'All Aspects of the Artefact' *Times Educational Supplement* 27 October 1978).
J.B. Penfold and M.A. Smalley 'Attitudes to Craft, Design and Technology' *Craft Design and Technology in Durham Schools* (Autumn 1978).

J.B. Penfold and M.A. Smalley 'Conferring at Shoreditch College' ILEA *Design and Technology News* (Spring 1979).

J.B. Penfold and M.A. Smalley 'Design Technology: Shoreditch sells it to the sixth form' *Craft, Design and Technology News* (January 1979).

J.B. Penfold and M.A. Smalley 'Handicraft: A Question of Attitude Change *General Education* (Summer 1979).

J.B. Penfold and M.A. Smalley 'Art, Craft and Design Technology' *New Sixth* (May 1980),5.

60. 'Craft and Design Teachers' Written answer *Parliamentary Debates Commons* 973 (5 Nov – 6 Nov 1979-80), 517.

61. J.B. Penfold and M.A. Smalley unpublished DES/Shoreditch College *Report: Opportunities for Women in Teaching Craft, Design and Technology* (1980).

62. Crafts Advisory Committee *Analysis of the questionnaire on training for craft teachers* (1979), 18.

63. Standing Conference on Schools' Science and Technology' Inquiry into current shortages of specialist teachers of mathematics, the physical sciences and craft, design and technology *Report of the Working Party* (April 1980).
See 'Teaching crisis plan of action' *Evening Standard* 22nd May 1980); 'Pay rise for scarce teachers no answer to shortage' *The Guardian* (23 May 1980); Pay maths and science more call' *The Times Educational Supplement* (30 May 1980); 'Are the right teachers applying for re-training?' *Education* (30 May 1980).

64. G. Hicks 'CDT: The Position and Future Projections' *Practical Education* (18 April 1984).

65. DES *Teachers in Service and Teachers Vacancies 1984-5 Statistical Bulletin* 3/86. (1986).

66. 'Craft and Design Teachers' *Parliamentary Debates Commons* (73 (1979-8-, 5 Nov – 16 November), 517 written answers.

67. DES Conference of Lecturers from Craft, Design and Technology Teacher Training Institutions *Conference Report* (July 1982), 8.

68. Schools Council *Project Technology Pilot Study Report* (6 November 1967).

69. DES Conference of Lecturers from Craft, Design and Technology Teacher Training Institutions *Conference Report* (July 1982), 33.

70. Standing Conference on School Science and Technology *Autumn Conference Report* (November 1979), 25.

71. S. Thomas 'On the trail' *The Times Educational Supplement* (19 October 1985), 33.

72. J.E. Morpurgo *Barnes Wallis* (1981), 342. Ian Allan Ltd.

73. Ibid., 21; See also Royal Society of Arts 'Man the Creator' *The Journal of the Royal Society of Arts*. 114 (September 1966), 812-822.

74. M. Norman 'The teachers who can sell their skills to the highest bidder *The Daily Telegraph* (20 August 1985).

75. Standing Conference on School Science and Technology, R.L. Page and J.M.U. Nash, A survey of fourth form secondary school pupils *Attitudes to Technology and Industry* (March 1980), 3.

76. University of Oxford Department of Educational Studies, M. Nash, T. Alsop and B. Woolrough *Factors affecting the uptake of technology in schools* (1985).

Chapter 4

FROM HANDICAFT TO CRAFT DESIGN AND TECHNOLOGY

A wealth of statistics and the self-evident buoyancy of the subject today, convince many that the age of fulfilment in CDT is dawning. A more cautious assessment which pays due attention to its history, would be less optimistic. A study of the ideas, policies and events which span the post-war transition years from handicraft to CDT shows a pattern that is far from orderly. The pendulum of change has swung violently, propelled by rival personalities and pressure groups, but never quite violently enough to clear all obstacles from the path.

Manual Instruction: headmasters' evaluation
To be clear about the underlying causes of curriculum change in CDT after 1945 it is necessary to understand what led up to the changes. Factors which initially influenced the introduction of manual instruction, instead of providing a launching pad, had by the close of Queen Victoria's reign, largely determined the mundane course taken by practical subjects for the next fifty years. In 1898 the Joint Committee conducted an enquiry into 'the development of work in connection with manual training'.[1] Many of the comments are pertinent today. With one exception, the headmasters who submitted evidence to the committee were generally well pleased with the London scheme and offered few suggestions 'for the expansion of work'. Only the recommendation that technical drawing should form a separate subject was positively received and proposals to extend the provision of metalworking centres met with a poor response. On the educational value of woodwork, however, the Headmaster of Burghley Road declared:

> Of this occupation I have no word but praise. No more useful nor popular occupation could have been devised.

His views were echoed:

> I have found the work of a great relief to the ordinary 'brain' work and helpful to it, and its effect upon the boys, educationally excellent . . . I have been delighted with the work in every respect and especially for the means it affords of developing the creative faculty.

Such evidence led the Joint Committee to conclude that:

the success of any scheme and the results to be obtained seem to us to depend entirely on its being in accordance with the complete design of the teacher, and the amount of enthusiasm which he puts into his work. Perfect freedom, therefore, should be accorded to the teacher in the formation of his syllabus, only general principles being laid down.

Despite these affirmations of the value of manual training, there were headmasters conscious of its deficiencies and some who even boasted of 'never having been inside a workshop'. One critic who gave evidence to the committee, Seth Coward, headmaster of the Alma Board School in Southwark, had been favourably disposed to manual training but, after ten years of association with the new subject, he identified weaknesses which were to prove difficult to eradicate.

I have been sending boys to the Woodwork class, the work whch is carried out quite independently of the rest of the work of the school. For that reason, among others, the results have been to me of a most disappointing character . . . I have been reluctantly forced to the conclusion that its effect on the general intelligence of the boys is scarcely perceptible. The sacrifice of one-tenth of a lad's time for the last two years at school is a very serious matter. The results are entirely out of proportion to the actual expenditure of time and force in the work, to say nothing of the dislocation of the ordinary work of the school. The same amount of time devoted to Mensuration, or Algebra, or Euclid, or Art, or Science, would be in my judgement, from all points of view, much more effective in securing the objects for which the school exists.

In Mr Coward's opinion, manual training had been largely irrelevant to improving the career prospects of boys leaving his school. He had 'only known three for four cases in which it has influenced employment in after life'. Remember that the Joint Committee and the School Board for London had resisted any form of trade training.

Elsewhere, however, headmasters reported that boys who had undergone a course of manual instruction were

much sought after by manufacturers . . . At Clapham there were the works of an optician who preferred boys from that school who had been through a Manual Training Course to boys from other schools. He considered that Manual Training helped boys to get out into life.

And that:

as testimony to the value of this training, I have had several applications from employers in the district, asking for boys who had taken a course of lessons in woodwork, to be sent to them when leaving school: and other employers have expressed their appreciation of the boys who have worked for them.

Even more advantageous to future employment was technical drawing. According to the Head of William Street Board School in Hammersmith:

That the training of the school, though intended to make handicraftsmen rather than mere draughtsmen is shown by the fact that scarcely a year passes without some of the boys entering builders', surveyors', architects', or engineers' drawing offices, where at an early age some of them have obtained very good wages

and the Head of Haselrigge School, added that: 'Manual Training, and especially Drawing, helped boys to get good employment'.

The committee also received evidence that practical work was of educational value for the below average pupil. According to the Head of Halford Road School in Fulham

For boys, who are dull in all 'brain' work, and whose only hope is in mechanical work — writing, drawing, colouring, measuring, in which alone they can be profitably instructed . . . Woodwork would be a delight and a real benefit.

The Chairman of the School Management Committee, Graham Wallis, was, however, disappointed that Solomon Barter's addendum based on the evidence submitted did not offer

any immediate solution of the present educational difficulty in the organisation of Manual Training . . . The existing want of co-ordination is not only a theoretical anomaly, but also a cause of practical and serious educational evils.

By the turn of the century, any lingering expectations that manual instruction had a distinctive role in the regeneration of British industry had faded. The support of the industrial lobby evaporated: practical work has to be taught for educational reasons. But the legacy of a teaching force largely of skilled craftsmen, who taught in centres some distance from the contributory schools, militated against this. The Joint Committee observed in its report that:

. . . many of the Instructors are artisans first and instructors afterwards. They have not as yet an intelligent grasp of the educative principles underlying the work, nor of the Head Teacher's views respecting the end to be obtained.

These weaknesses, first identified in the capital, were soon compounded by the appointment of ex-artisan London teachers to education authorities throughout the country. Everywhere the teaching of woodwork predominated. Early circulars issued by the Education Department intended for the guidance of teachers and to encourage a diversity of approach, in reality resulted in the reverse. They fostered an unwanted degree of conformity among workshop teachers and elevated the teaching of skills and constructions to the detriment of everything else. The Board of Education's *Handbook of Suggestions for*

Teachers, essential reading for generations of student teachers through a number of editions, did much the same. The last, 1944 edition stated still:

In Woodwork, for example, a boy must learn how to make the basic joints if he is ever to make anything worthy of the craft. In Metalwork there are various tool processes demanding great care and accuracy, while they can be most boring and discouraging if taught unintelligently, can, on the other hand, become really interesting, if approached in the right spirit.[2]

Post-1944 Reorganisation

R.A. Butler's Education Act was a watershed in the history of secondary education in Britain. Raising the school leaving age from fourteen to fifteen when the birthrate was rapidly rising meant that an extra million children needed to be educated. This necessitated an urgent building programme and expansion in the provision for teacher training. Secondary education was restructured. The tripartite system emerged, in theory if not in practice. Elementary schools, a nineteenth century relic, were finally swept away and replaced by secondary modern schools. Technical schools, vigorously supported by Herbert Morrison and Chuter Ede, and seen as an essential element in the fight for national survival, were wedged between them and grammar schools which it was hoped would broaden their intake and not be wholly class biased. It was believed that these changes would encourage the most able children to fulfil their early promise and that the huge new investment in education would, at last, enable all children to develop in accordance with their age, aptitude and ability. Deep seated prejudices against practical work and long memories of the pattern and provision for workshop teaching within the old elementary system meant that practical subjects were relegated predominantly to the domain of the lowest stratum — the secondary moderns. In Grammar schools they were generally a peripheral activity. Technical schools, which could have given practical subjects a boost, were never founded in the numbers envisaged in the 1944 Act[3]. Difficulties associated with the reorganisation of the secondary school structure were made worse, as we have seen, by the shortage of properly trained teachers adding another strain to the new system. Despite this, it was in a spirit of controlled optimism that educationists tackled the enormous problems of adjusting from a wartime to a peacetime economy and responding to the ambitious requirements of the Butler Act.

Dissatisfaction with traditional craft teaching values

Very soon, however, some craft teachers began feeling that the extended secondary school curriculum, by still reflecting the values of an earlier era, was ill-suited to the changing aims and expectation of post war education. Once more disagreement mounted. On the one hand, traditionalists (not all old) elevated, taught and tested performance in manipulative skills as if they were the *raison d'etre* for teaching woodwork and metalwork. On the other, progressives (not all young) focused attention on questioning the *a priori* assumption that the acquisition of manual skills, of little direct relevance to the society in which the

boys were maturing, had to precede educationally more fulfilling goals. In between, a not inconsiderable number found themselves trapped between hammer and anvil.

Latterly the banishment of the sorcerers of skill has, in some quarters, begun to take on almost moral overtones: craftsmanship as the unacceptable face of workshop activities. The ghost of William Morris had to be exorcised. This had not always been the reaction to craft values. As a young teacher in a Middlesex secondary modern school for five years, the author like most of his contemporaries had a thorough grounding in woodwork and metalwork, aspiring always towards the highest standards of skill and finish. At Shoreditch Training College and Loughborough College, Arts and Crafts values were highly esteemed. At Loughborough, the late Edward Barnsley, continued to provide a direct link with the Cotswold 'Utopian Craftsmen'. As the majority of lecturers in handicraft elsewhere had themselves trained at Loughborough or Shoreditch, these ideals were widespread.[4]

For teachers imbued with these ideals and with only a short period of teaching practice behind them, being thrown into the hurly-burly world of secondary modern teaching was something of a culture shock. For each boy who could produce a decent row of dovetails, far more could be found discovering the doubtful joys of brummer stopping or applying a viscous paste of sawdust and glue to fill up the only too obvious gaps. A backlash against the over-emphasis on standards of craftsmanship was inevitable. Nowadays, most students have difficulty in distinguishing between William Morris (later Lord Nuffield) of Morris car fame and William Morris the designer and should perhaps know something of both. Ironically, William Morris is now recognised as a seminal nineteenth century thinker — outside of CDT circles. No longer is he regarded as a backwoodsman, a medievalist, a Luddite who scorned the use of machinery. The exhibition organised by the Institute of Contemporary Arts in 1984, 'William Morris Today', celebrated him as poet, pamphleteer, conservationist, pioneer of modern design, craftsman, designer and an intellectual giant whose radical thinking has continued to inspire social and political theorists throughout this century.[5] Nor was Morris personally opposed to the installation of machinery, as he himself declared:

> I have spoken of machinery being used freely for releasing people from the more mechanical and repulsive part of necessary labour, and I know that to some cultivated people, people of the artistic turn of mind, machinery is particularly distasteful, and they will be apt to say you will never get your surroundings pleasant so long as you are surrounded by machinery. I don't quite admit that; it is allowing machines to be our masters and not our servants that so injures beauty of life nowadays. In other words, it is the token of the terrible crime we have fallen into of using our control of the powers of Nature for the purpose of enslaving people, we care less meantime of how much happiness we rob their lives of.[6]

Is this to make much of a diminishing influence? Diminishing it may be, but it continued as broadly the basis of most teacher training courses until the sixties. Approximately half of those currently involved with teaching of CDT at all levels will have been directly or indirectly influenced by the ideals of the Arts and Crafts movement. To reduce them to romantic nonsense or a drag on the development of CDT, is divisive and unhelpful and could lead some insecure teachers to withdraw further into their protective shells. This is not to defend obscurantist practices, but not all the past was bad. Despite perceived shortcomings, much curriculum development in CDT since 1945 originated through the vision and efforts of men drawn from conventional handicraft backgrounds and there is no reason why this should be a source of embarrassment. It is time CDT abandoned its self-defeating bouts of in-fighting.

Metalwork catches up

The pace of change since 1945 must not be exaggerated. Metalwork teaching, for so long the neglected partner, had much ground to make up. In an endeavour to narrow the gap, the Ministry of Education published *Metalwork in Secondary Schools*.[7] It helped bring about a parity between woodwork and metalwork provision, but not until the sixties. The advantage of metalwork, it claimed, was that there was no need for skill training courses as in woodwork, so pupils could immediately start making useful objects. For younger pupils, tool-making projects were particularly recommended: advice that proved to be remarkably effective and long lasting. Advanced instruction for older pupils consisted of themes derived from instrument making, model engineering and hammered metalwork. It is interesting that in the fifties, whereas some woodwork practitioners were wrestling with constraints imposed by prescribed designs, metalwork teaching, with the exception of forge and hammered metalwork was being urged to adopt a policy that, for many pupils, permitted little individual response to the design of the objects to be made. Not all followed this policy.

The section on 'Design for metalwork' did not point the route that many metalwork teachers, along with woodwork colleagues, were soon to pursue.[8] The stimulation of design awareness and considerations of functional design were certainly well to the fore but the possible direct involvement of boys in the design of their own work was only barely perceived. Design for most amounted to a consideration of 'alternative methods of construction or choice of decorative treatment enabling them ultimately to design by selection'. Only the 'more gifted boy', the pamphlet maintained, had the ability to 'plan a piece of work on paper and then to carry it through to its conclusion'. According to the Inspectorate, of even this select group, 'perhaps not more than two or three each year may possess in addition, creative imagination' from whom 'may be expected some success in design at the end of a four year course'.

Sydney Glenister, principal lecturer at Trent Park College of Education, in his book *The Techniques of Handicraft Teaching* published a year after the Ministry's pamphlet, echoed this theme, asking: 'Can the Children Design'[9] He concluded that, though some theorists had advocated children should design their

own projects, 'teachers who have practical experience in this direction well know that very few children have either the skill or the aptitude for this work'. Consequently, he recommended that teachers should develop in their pupils 'a sense of good taste and an appreciation of good design . . . and to co-operate in the planning' (of their work). His own interpretation of design was somewhat questionable but widely heeded and perpetuated an approach to furniture design which led to it being widely lampooned by professional designers. Design, instead of being taught as an entity, concentrated almost exclusively on matters of styling, shaping and decoration. Children's contribution to design, according to Glenister, could best be made through such items as handles. If a teacher designed everything connected with a box except the handle, the boys could have:

> freedom to use their own imagination in designing and making these. As each of these handles would use only a scrap of wood, no harm would be done in allowing each boy to make three or four handles of different design. This could be followed by a short discussion on the merits of each design. None of the handles any one boy made might be suitable enough to be put to practical use but at least he would have been taught the requirements for a well-designed handle.

Glenister was a prolific author and his *Contemporary Design in Woodwork* was the most widely used school handicraft book in the 50's and 60's. His approach to design was widely copied, not least by examination boards. Many children developed design concepts that revolved round multiple premutations of tapering the inside of a leg and shaping the underside of rails.

It was time for a change. Many handicraft teachers felt their subject was not making headway. Few were dissatisfied with the teaching of skills as such; it was the context in which they were used and the end products themselves. When, for example, a Ministry pamphlet suggested making a pastry cutter (essentially an exercise in tinplate work ensuring a working knowledge of safe edges and soldering techniques) plastic ones, superior in every way to the home-spun variety, were coming onto the market. Indeed plastic articles began to make extensive inroads into the stock-in-trade of many workshop produced articles. Into this confused world sailed an unlikely craft: a tug boat. When Robin Peddley (now owner of Peddley Woodwork and probably the first millionaire to come from handicraft teaching, and a Shoreditch Diploma student in the late forties) produced a series of tug boats, could he have foreseen the consequences? The tug boats, appealing, brightly coloured and childish, epitomised the new approach. They had remarkable seaworthy qualities and commissioning services are still held annually in schools up and down the country, and even as far as Hong Kong. The tug boat succeeded because it intuitively encapsulated the ideas of the many teachers not seeking to create monuments to posterity. Like child art, it conveyed a meaningful yet ephemeral message, communicating educational ideas that could be justified in their own right and not just as steps towards more advanced cabinet-making exercises. But it was not a total breakthrough: these early, tentative experimental years were not always blessed with success, however, and

traditionalists glowed with satisfaction as they witnessed the scrap boxes of their more venturesome colleagues filled with the week's rejects.

The Crowther Report

Whatever progress was being made within the subject, externally, handicraft continued much as before. In 1959 it received one of its periodic boosts from higher authority which has been a regular feature of curriculum development over the Years. The Crowther Report of 1956 asked the Central Advisory Council for Education:

> to consider, in relation to the changing social and industrial needs of our society, and the needs of its individual citizens, the education of boys and girls between 15 and 18 (the school leaving age then being 15), and in particular to consider the balance at various levels of general and specialised studies between the ages and to examine the inter-relationship of the various stages of education.[11]

Crowther argued persuasively for an 'alternative road' approach to education to enable the country to benefit from the capabilities of all its young people. The Report advocated the rehabilitation of the word 'practical' in educational circles even though it was aware of its ambiguity: 'practical' carrying pejorative overtones, frequently being construed as the opposite of 'academic'. The Report strongly refuted such a view:

> The boy with whom we are concerned is one who has pride in his skill of hand and a desire to use that skill to discover how things work, to make them work and to make them work better. The tradition to which he aspires to belong is the modern one of the mechanical man whose fingers are the questioning instruments of thought and exploration.[12]

The Crowther Report was the first major post-war initiative to address itself to bridging the gap between education and industry. It met with a mixed response. Edward Semper, headmaster of Doncaster Technical High School and a dominant figure in technical education in the fifties and sixties, lead the way in the promotion of the idea of curriculum research into applied science.[13] Craftwork was taught as an 'instrument of general education' at his school. Semper was clear about its philosophy:

> The Doncaster Technical High School differs from a grammar school mainly in that it has a broad vocational aim and is unashamedly science-based. The applications of science are used to bring intelligent interest to the crafts and to create an awareness of our cultural heritage as well as to vitalise the teaching of pure science. The ethos of the school is conditioned by technology which, far from restricting the process of education, provides a most engaging means of stimulating interest and sustaining effort.[14]

With the growing comprehensivisation of the secondary school system, Semper was instrumental in changing the nature and title of the Association of Heads

of Technical Schools to the Association for Technical Education in Secondary Schools. The principal concern of the new association centred on securing a proper place for the teaching of young people through scientific applications, embodied in Crowther's 'alternative road' approach.

The beginnings of school technology: science or handicraft based?

In 1964 Harold Wilson became Labour Prime Minister. He declared that the 'white heat' of the technological revolution would ultimately permeate every aspect of our society. The Institution of Mechanical Engineers, aware that engineering was failing to attract a sufficient proportion of brighter pupils, sought to ascertain the extent of engineering activity in schools, and found it in less than five per cent of them.[15] Forty of these schools were visited. Of this handful, thirteen were in the independent sector, seventeen in publicly maintained grammar and ten in technical high schools. Further information came from a questionnaire to a further 265 schools. Engineering proved to be very much the province of the science department. This survey by Graham Page dealt with a spectrum of teaching a world away from that of the great majority of handicraft teachers, but he was sympathetic to the potential value of workshop subjects to engineering.[16] The future scientist, every bit as much as the future engineer, Page claimed, needed a basic competency in skills and constructional techniques that were best taught by the craft teacher. A number of influential figures in applied science teaching disagreed. Gerd Sommerhoff, whose Technical Activities Centre at Sevenoaks School did much to put technology teaching on the map, put the case against technology evolving out of workshop subjects;

> Manual skills are no substitute for creative thought. It is our belief that the traditional kind of school metalworkshop can do more harm than good to the engineering profession. It fails to attract brighter children and it leaves children with the impression that to become an engineer is the same as to become a machine operator or mechanic. This, of course, is one of the common confusions which have brought the status of the engineer so much lower in this country than in other industrial countries.[17]

Sommerhoff's centre was designed as distinct from the craft department which continued to flourish independently, fulfilling a quite different curriculum role. When the centre opened in 1963, the main activities focused on 'mechanics, aeromodelling, electronics, radio controlled models, computers and automatic devices of all sorts'. Over the next twenty or so years the school considerably extended this range. By 1983 the list of basic courses consisted of: elementary mechanics and the use of Meccano, engines and how they work, the lathe, elementary aerodynamics and windtunnel experiments, model aircraft construction, and glass fibre moulding, elementary electricity and circuit design, electro-magnetism and its uses, electronics Parts 1 and 2, Boolean algebra, transister logic and integrated circuits, operational amplifiers, microprocessors Parts 1 and 2. Additionally the school runs formal courses on computer programming. A key feature of Sommerhoff's organisation was that pupils were expected to have mastered

the basic principles of their subject and acquired basic practical skills before they could embark on project work. To this end he developed a range of programmed self-instruction courses combining practical and theoretical elements, each consisting of a folder of some 30-50 pages of text. Pupils did the courses individually and at their own pace, supervised by the teacher. Sommerhoff found by experience that his boys did them willingly and well. The Sevenoaks approach attracted widespread attention, finding particular favour with the Federation of British Industries which wished to see Sommerhoff's system extended and adopted elsewhere. Others were less sure. They pointed out the highly favourable circumstances surrounding the Sevenoaks experiment — an innovative and dedicated teacher, excellent facilities, clever children who did the work as a voluntary activity out of normal school hours, good access to materials and components and the special nature of public school education.[18] Be this as it may, Sevenoaks did much to popularise technology teaching in the sixties. Gerd Sommerhoff appeared frequently on television, especially in connection with the BBC's Science Fair programmes. A book and various articles published on the school together with a film 'Creativity in School' stimulated interest in the experiment.[19]

In the maintained sector, the applied science department of Ealing Grammar School pioneered the teaching of technology at sixth form level. Dr G.T. Sneed, who became head of science, wrote to Professor Blackett at the Ministry of Technology outlining the principles of the course. His letter claimed that:

we are the only grammar school in the country which has created a special course whose aim is to try and persuade able boys in the science sixth to take engineering degrees at the university.[20]

Like Sommerhoff, he saw a clear demarcation between school metalwork and engineering. Sneed, who developed the work at Ealing over nearly twenty years, though conversant with developments in CDT remained unenthusiastic, writing in 1983 that some craft teachers wished to 'elevate' their subject 'to the peerage'.[21]

The friction or downright hostility between the scientists and the applied scientists in one camp and those who advanced the idea of technology from a handicraft base in the other, have been exhaustively explored in a recent study.[22] The author is indebted to this source for much of the information in the following section. Dr Gary McCulloch, Edgar Jenkins and Professor David Layton have described the complex interforces which led to the wider introduction of technology into the secondary curriculum and their account should be familiar.[23]

The potential contribution that craft teachers could make to technology teaching owes much to the almost visionary thinking of Donald Porter, then staff inspector for handicraft at the DES, who believed strongly in the alternative road approach. In 1964, he spent a sabbatical year exploring ideas that would extend the teaching of technology in secondary schools. The movement to merge grammar, secondary modern, and technical schools into a comprehensive pattern of schooling made his studies especially timely. The Schools Council published

Porter's research two years later,[24] and when they were considering a feasibility study for the teaching of applied science and technology, Porter wrote in a supportive background paper in which he suggested that mathematics and science teachers might be encouraged to 'tackle jobs at boy level in an engineering way'. This required optimism was not held by all.[25] Despite NUT reservations that support for engineering in schools owed more to the universities and the engineering institutions than to the schools themselves, the Schools Council launched 'Project Technology'. Its stated objective was

> to help all children to get to grips with technology as a major influence in their lives, and as a result, to help more of them to lead effective and satisfying lives.[26]

Over 500 hundred schools from all parts of the country were interested in participating. They were divided into geographical teams linked with universities and departments of education under the overall control of the project leader Geoffrey Harrison, based at Loughborough College. To underpin its curriculum development role, the Project Technology team's activities extended from the provision of attractive teaching material to supportive research programmes. These included investigating the educational value of technological project work, its assessment and evaluation, influences affecting girls' attitudes to technology and the development of creative ability but strained resources meant that this could be only superficial.

The authors of *Technological Revolution?* cast G.B. Harrison as the champion of the craft route to technology teaching. Harrison publicly disputed Sommerhoff's assertion that the technical project work at Sevenoaks School was superior to metalwork, maintaining that 'technical activities and metalwork are complementary, mutually supporting and of equal importance'.[27] Whereupon H.N. Pemberton and Brigadier J.R.G. Finch, chairman and secretary of the Council of Engineering Institutions, visited Ealing Grammar School and declared their support for its course, based on science, not craft. To reinforce the Ealing approach, vacation courses intended 'essentially for science masters, or science teachers and not craft teachers, since Sneed's work has nothing whatsoever to do with craft training' were proposed.[28] Representatives from the Association for Science Education and the Council of Engineering Institutions formed an Action Group, which had the ear of the Duke of Edinburgh. The Group aimed to advance the teaching of technology through a reform of the school science curriculum, and to exclude the 'craftsmen'.[29] Hostility was ill-concealed and attempts to reconcile the two approaches foundered because of their fundamental differences. Professor Kevin Keohane, coordinator of the Nuffield Foundation Science Project and a member of the Advisory Committee of the Schools Council Project Technology, confided his own reservations to Lord Jackson:

> between ourselves I can't say I have been entirely happy. It may be doing a good job at craft level, but I feel that it is not, perhaps, likely to make an impact on the most able pupils whom all of us would wish to enter in greater numbers, to courses in science and technology.[30]

Donald Harlow a scientist with a technological background and an official of the Science Masters' Association confirmed this view:

> It seems clear that his (Harrison's) project will not produce greater numbers of scientists. It is craft based; it uses the facilities and staff of the handicraft sections and is in many cases being handled entirely by the handicraft departments of LEAs without reference to science staffs.[31]

The relationship continued to be strained between the scientists and Project Technology and meant that valuable opportunities were lost to press for more technology teaching just when the climate for change was especially favourable. Some progress was made when the Standing Conference on School Science and Technology (SCSST) based at the Institution of Mechanical Engineers and the Science and Technology Regional Organisations were founded. The SATROs were set up to nurture contacts between schools and technological activities at local level. When Project Technology completed its five year span funding continued for a further two years. Geoffrey Cockerill, the Schools Council Secretary, professed his satisfaction with Project Technology;

> It had become widely known in colleges of education as well as schools, has produced some attractive materials, and — viewed as a research and development project — generally fulfilled the expectations envisaged for it by the Council.[32]

This account is astonishing in being totally out of touch with the perceptions of most handicraft teachers then in the schools. Science teachers were apparently expecting their territory to be occupied by a vast army of handicraft teachers led by Geoffrey Harrison and his Project Technology team. Nothing could have been further from the truth. Virtually every craft teacher was very sceptical of the claims being made for technology in craft shops if not actually opposed to them. Geoffrey Harrison established his technological reputation at Dauntseys Public School and encountered much criticism from colleagues in state schools. His appointment to head of the craft department at Loughborough College in 1965 caused resentment among college staff and ex-Loughborough students who saw him as a betrayer of craft education values. When Edward Barnsley was obliged to leave, this so angered some of those trained at Loughborough that they stopped recommending their old college to sixth formers. Loughborough's output of CDT teachers has never recovered. The majority of craft teachers who spent most of their time teaching average and below average boys, also found that the Project Technology material was beyond their pupils and were not even sure of their own ability to cope.

David Tawney, in an evaluation of aspects of Project Technology, seems to have underestimated the resistance of most craft teachers to technology teaching.[33] Teachers participating in Project Technology were not a representative sample of craft teachers. This sample, however, was satisfied with Project Technology teaching materials and publications. A high proportion of them did depend on these materials for their teaching but it is uncertain how many

schools introduced or strengthened their teaching of technology through involvement with Project Technology. Many schools taking the publications did not implement curriculum change and others did not sustain the changes made. If individual teachers had been visited by the central team, Tawney suggested that they might have felt less isolated, and been encouraged. The number of schools teaching technology within craft departments settled between one and five per cent. Yet, when Project Technology was wound up at Loughborough College and the National Centre for School Technology established at Trent Polytechnic to continue the work, it gave the impression of being far more extensive. The cadre of teachers and lecturers were soon pouring out new material from Trent Polytechnic and developing a highly effective public relations operation which kept the teaching of technology high on the political agenda.

Average and below average pupils

Three years before the Schools Council set up Project Technology, the Ministry of Education published *Half our Future* (the Newsom Report), on education of 'pupils of average and less than average ability'.[34] The value of practical activities to the education of these youngsters featured strongly in the Report. It assessed their 'distinctive' contribution in providing opportunities of learning by direct experience and a medium of expression other than the written word. But ultimately, warned the Report:

. . . it all depends on the quality of the teaching. Unimaginative exercises can be as dully repetitive in woodwork as they can be in English. If practical work is to be used as a means of revitalising the programme — and it needs revitalising — for our pupils, something other than a larger dose of the mixture as before is needed.[35]

Extending craft teaching horizons in imaginative ways had implications for the education of all children, regardless of ability. The Report acknowledged the pride and satisfaction pupils might feel by doing something well, but did not consider it a sufficiently enriching educational experience in itself.

Learning and confidence had to be promoted by giving pupils real problems with which to grapple. Objects made in the workshop should work; if they did not, youngsters should be able to work out why. Time spent in the workshop was justified only if it. . . should lead to thought and expression: they are not to be regarded as a substitute for thought for the less intelligent.

Finally, the Report made a plea that craft studies should lead to a wider appreciation of manufactured objects to our cultural heritage: the development of feeling for the appropriateness of materials to their use; responsiveness to colour, form and design and the enhancement of sensitivity towards the personal and social needs of human beings in relation to their environment.[36]

The Keele Project

The Newsom Report addressed itself directly to problems and opportunities con-

121

sequent upon raising the school leaving age from fifteen to sixteen in 1965. Craft teachers, whose main teaching commitment had always been with the average and below average boy, were soon up to their necks with ROSLA (Raising of the school leaving age) schemes that stemmed from Newsom recommendations. In the longer term, however, the Newsom philosophy found a more cohesive and explicit outlet in the Schools Council Design and Craft Project. Early ideas for the research programme were first explored at Leicester University Department of Education under the direction of Professor G.H. Bantock. When John Eggleston, then a lecturer at Leicester University, became Professor of Education at Keele University, the work went with him. Known initially as the Schools Council's 'Research and Development Project in Handicraft', the research team soon established a working relationship with large numbers of teachers throughout the country.[37] The DES and the Schools Council may well have seen Project Technology, the Keele research and the Art and Craft 8-13 project at Goldsmith's College[38] as three curriculum development programmes that together would reinvigorate and give more purpose to workshop teaching. This may indeed have happened at the time but not many teachers saw it like that. Most regarded the Projects as tugging in opposite directions. Far greater numbers of craft teachers identified themselves with what became universally known as the Keele Project than with Project Technology. In part this can be attributed to the greater willingness of the Keele research team to visit centres throughout the country to explain their aims. More significantly, the Keele Project was more attuned to the backgrounds and aspirations of the majority of handicraft teachers then looking for ways forward. But even the Keele Project had its limits and many schools carried on as if the two Schools Council research projects did not exist.

The pilot study, *Education through the use of materials* only partially indicates the direction of the research team.[39] Craftwork, by combining the teaching of skills with the stimulation of pupils' own creative ideas, could afford a demanding and enriching educational experience, whilst craftwork consisting solely of making tangible end products in one material only restricted educational opportunities.

The Report's proposal was to look at the possible integration of craft work with other areas of the curriculum in which 'work with materials in the workshop plays a central part', naming art, home economics and technology as especially appropriate. The seeds of the circus arrangement had been sown. More immediately, an appendix associating craftwork with all-embracing curriculum objectives including intrinsic and extrinsic motivational factors, personality traits and attitudes, creative and skill development and the fostering of logical problem-solving strategies may have reassured handicraft teachers about the educational base of their subject, but fell short of proving the extensive claims being made on behalf of the subject.[40]

Creativity — the 60s background
Professor Eggleston's team proved eclectically adroit and responsive to the characteristic creative mood of the sixties, with its explosion of talents in fashion,

film and theatre, commercial photography, advertising, pop music and pop art. Terrence Conran pitched his 'Habitat style' to a design-conscious middle class. Philippe Garner aptly summed up the time:

> Consumerism was a new thrill to be judiciously enjoyed and the tastes of this public were to be nourished after 1962 by the colour supplements to the Sunday newspapers — first with the Sunday Times, then with the Observer. With such features as the Sunday Times 'Design for Living', the supplements, as much in their advertising as in their editorial content, provided a pot-pourri of instant consumer culture and contributed to the visual education of a very wide market.[41]

An interest in all things creative spread. It permeated space race thinking and influenced America to believe that its future society depended on the creative discoveries and innovations of its scientists and technologists. Creativity research flourished.[42] Social psychologist Irving Taylor analysed over a hundred definitions of creativity and identified five levels of creativity which entered the educational vocabulary: thus came 'expressive creativity', 'productive creativity', 'inventive creativity', 'innovative creativity', and the highest level 'emergentive creativity'. Open-ended creativity tests designed to measure performance, mushroomed. How many uses for a brick, a matchstick, a paper clip . . .? High scores predicted creative potential. This led researchers — J.W. Getzels and P.W. Jackson, Carson McGuire and Irwin Flescher — to draw differing conclusions concerning the relationship between intelligence and creativity. Other psychologists directed their attention to now familiar brainstorming and synectic techniques. Much of this academic research had direct relevance for teachers. Torrence's work, for example appeared to support the thesis that educational pressures encouraged conformity in children. Education was thus held to be a powerful agent for suppresing 'divergent' and encouraging 'convergent' thinking. Liam Hudson's academic research at the Cambridge Psychological Laboratory even caught the popular imagination when he suggested in a book published by Penguin, that 'convergent' thinkers tended to be attracted to the physical sciences and 'divergent' thinkers to history and literature.[43]

Younger craft teachers proved very receptive to these stimuli; so receptive that even the appearance of many became transformed — short back and sides gave way and grew into flowing locks and sideburns and out went the time-honoured national dress of the fraternity. Well worn, elbow-patched sports coats, with top pockets of gleaming pens were discarded in favour of leather and suede jackets and coloured shirts. These trappings, emblems of the permissive society and of upwardly mobile teachers, caused consternation amongst staid members of the profession. But in reality the momentum was in the other direction. Design for craft teachers acquired new connotations.

The birth of design education
Whilst *The Woodworker* remained possibly the most widely read periodical among handicraft teachers, *Craft Teacher News* and Stanley's *Craft Education* (both cir-

culated free of charge at first) began to include articles of wider interest. Readership of *Design,* the more prestigious journal of The Council of Industrial Design (now the Design Council) grew steadily among workshop based teachers. During the sixties, they found much in the journal that was relevant to their work. One editorial sympathised with the movement to institute a combined approach to the teaching of design education in secondary schools but advised a realistic attitude.[44] To ignore 'the powerful and legitimate pressures' on the curriculum exercised by those brought up in a non-visual tradition, would be politically naive and jeopardise the implementation of design objectives.

Kate and Ken Baynes examined the state of design education in two articles in *Design.*[45] The first concentrated on the Leicestershire plan, where the director of education, Stewart Mason, believed practical subjects, art, drama and music, to be a fundamental part of every pupil's secondary education. The authors found that woodwork and metalwork were taught in handsomely provided accommodation but observed that:

> . . . educationally and intellectually there was an anachronistic atmosphere about the craft room and the methods used were, with the backing of conservative-minded teacher training colleges, extraordinary impervious to change . . . Only with the dissatisfaction of a younger generation of teachers, who have felt the inadequacy of the traditional teaching methods, has craft begun to grope its way along the tricky path from cosy certainty of learning known hand techniques towards a broader consideration of the construction and function of objects in an industrial society.

Their second article looked at teacher training provision for craft and design education at Cardiff, Hornsey, Shoreditch, Loughborough and Goldsmiths College. Shoreditch with an intake of 240 students in 1966 was the obvious representative of the traditional approach. Ted Sawdy, the head of the craft department, was not one to bow to the winds of change and told the Bayne's that:

> The aim of the course is to send out teachers who will teach in all ranges of secondary education, their main medium of education being woodwork and metalwork . . . The breadth of the courses is to enable them to use their specialisation as a means of educating boys to an appreciation of fine craftmanship and good design, and to give avenues for personal intellectual and emotional development.

Ken and Kate Baynes who thought the teacher training college was 'the obvious place to break into the educational cycle needed to bring about change' saw Shoreditch as a major stumbling block, as so did many of the younger Shoreditch staff. Yet the role of teacher training institutions in curriculum development was not as straightforward as they made out. They were more positive about developments at Hornsey and about Loughborough's tentative steps towards technology. This alerted the them to the potential of technology within the field of design education, but this was not really happening. Design education almost universally excluded technology teaching, and still does.

Design educationalists were effective in publicising their cause. A conference held in February 1969 at the NUT headquarters assembled an impressive list of speakers, headed by Shirley Williams, then Minister of Education.[46] She told delegates that:

> When it comes to the teaching of design itself, I hope very much that schools will not regard the teaching of design as being something that takes place in the woodwork class, or the craft class, or the home economics class or the art class . . . the design approach is also just as badly needed in the engineering workshop, in the metal shop, as in the woodwork shop. It is needed beause the future technologist, or the future engineer, must be as conscious of the possibilities of design in what he is doing, as the future designer must be conscious of the limitations imposed by different methods of production.[47]

One positive outcome of the conference was the proposal to form the Association for Design Education. Sir Paul Reilly, Director of the Council of Industrial Design, hoped that the new association would stimulate teachers of children of all ages and subjects to take 'design under their wing', not as specialists but as part of the general knowledge with which all boys and girls should leave school. Only in this way would future generations 'grow to speak the language of design as fluently as their mother tongue'. Other outcomes of the lobbying are discussed below.

Design education literature
Publishers were quickly off the mark to satisfy the new demand. Books on design and design education began to roll off the printing presses. Some were trite: books with the same tired contents sold, provided the title — be it brass rubbing or basketry included the sixties buzz word 'creative'. Craft departments were eager to broaden their approach. At the time most traditionally trained teachers had never heard of the Bauhaus, nor the design philosophy of Walter Gropius. Colour, shape, form, texture and pattern were not part of their vocabulary till Maurice de Sausmarez's book described Bauhaus foundation course ideas derived from Johanes Itten's teaching.[48]

Kurt Rowland's 'Looking and Seeing' series were also phenominally successful.[49] His books illuminated the principles of visual appreciation of the natural and constructed environment, provided teachers and pupils alike with a sort of visual grammar to underpin their work. James Gosling recommended this 'splendid series' to members of the Institute of Craft Education;[50] interesting since the Institute tended to be known more as guardians of good traditional practice than as trailblazers. Most books on the principles of design were written by authors with an exclusively art background, but Francis Zanker, then a lecturer at Eaton Hall, produced a book which helpfully bridged the gap with craft.[51] In refreshing style, it gave craft teachers some confidence, building on, not debunking, their skills. Many craft teachers were enthusiastic about the Bauhaus exhibition in 1968 staged by the Royal Academy of Arts.[52]

David Pye, then Professor of Furniture at the Royal College of Art approached the understanding of design more analytically and was dismissive of some of the more voguish practices then in favour. It was a time when tables were no longer called tables; but were introduced in design problems as 'planes in space', and, chairs were 'structures to support the human frame'. Was Professor Pye right? It would be interesting to know how many innovative designs evolved from these unconventional approaches, but Professor Pye regarded them as 'idiotic' and declared:

> When the problem is old, the old solutions will nearly always be best (unless a new technique has been introduced) because it is inconceivable that all designers of ten or twenty generations will have been fools.[53]

This was nectar to the traditionalists and lucid thinking did bring into focus some design issues which had distinctly fuzzy edges. Soon after his book was published, Professor Pye was invited to lecture to a large audience of handicraft lecturers and teachers at the University of London Institute of Education. But the meeting was a flop. As one art colleague muttered 'they (the audience) may have picked up the odd word or two of the designer's vocabulary, but they don't understand the language' which may sound deprecating but sums up the communication problems that have led to much misunderstanding over the years.

Protagonists of design education produced books on the movement but these fell short of providing a coherent educational rationale that curriculum planners might use for future development. It may not have been what these pioneers wanted. They were primarily concerned to encourage fluidity, not to establish a possibly restrictive framework. The beginnings of design education make interesting reading. It arose more because of dissatisfaction with art teacher training, than as a bid to revitalize workshop teaching. Teacher training departments attached to colleges of art tended to be filled with frustrated would-be artists and sculptors. Course directors saw design education as a means of channelling their creative energy. This is not to disparage the work of Peter Green, head of the Teacher Training Department and Ken Baynes which made Hornsey College of Art (now part of Middlesex Polytechnic) immensely exciting. Ken Baynes, always an engaging writer, captured the spirit of the era in the contributions to his book *Attitudes in Design Education*.[54] The range of articles demonstrated the wide range he foresaw for design education. Including a piece by John Kingsland, the recently retired headmaster of Cray Valley Technical High School and one of the pioneers of the 'alternative road' approach, it broadened the concept of design education to include technological teaching. Peter Green's book also emphasised the key role of technology.[55] Technological education has not, however, been widely seen as within the scope of design education. Peter Green's book, apart from an enlightening introductory section, informed by example rather than precept. Bernard Aylward, the Leicestershire adviser offered brief personal opinions about design education in the volume he edited, but left his contributors to develop *their* ideas,[56] pointing out only that an integrated approach to design must be internalised within the minds of pupils and not be just an assemblage

of traditional subjects, each with its own specialism. All three authors gave no more than tantalising glimpses of the vision each had for design education. The lack of a rigourously argued educational justification for its inclusion within the curriculum left design education cruelly exposed when less favourable winds began to blow. The journal *Studies in Design Education and Craft,* from 1978, *Studies in Design Education Craft and Technology* reflected and encouraged new movements within handicraft. Edited from its inception in 1967 by Professor John Eggleston, it had its roots in the Institute of Craft Education and the College of Handicraft. The journal has provided the only consistent forum for the discussion and dissemination of fundamental curriculum development ideas in the craft and design area. The 1972 Winter edition carried a number of articles on integrated approaches to design education. Professor Eggleston, commented in the next issue, that these had provoked an unprecedented response, and he devoted the whole of the Spring number to the same theme.[57]

He hoped to deepen teachers' understanding of the resolution of practical design problems and, most importantly, to examine 'the underlying justification of many of the new approaches'. How influential *Studies in Design Education and Craft* was at the time is difficult to gauge. Its circulation then, of about 2,500, was relatively small, but the readership was far higher, especially among those able to exert pressure for curriculum change.

The substantive reports of the Keele Project demonstrated clearly the influence of ideas originating in design education.[58] Professor Eggleston, wearing his hat as Project Director, oversaw the transition of a project which began with a bias towards handicraft and ended with a more broadly based curriculum study area.[59] New parameters were set out. Problem solving strategies became the order of the day. Teachers acquired a new vocabulary. Design methodologies using analytical and synthetical criteria moved logically from need identification to optimised solutions and their evaluation. Ways of extending the material boundaries of wood and metal were explored. The text encouraged teachers to look afresh at the home, leisure and community work as sources for design-based studies. The work of the Keele Project completed, Eggleston brought all the competing and complementary design education influences together in a personal account of the movement during its formative years.[60]

The response of LEA Advisers

By the 1960s, advisers had effectively lost their organiser tag and formed themselves into the Conference of Handicraft Advisers to change again in the next decade into the Association of Advisers in Design and Technical Studies. A document, *Craft Education* published initially for the Annual Conference of Handicraft Advisers, aimed at stimulating further discussion among a wider readership.[61] Doubtless an awareness that carried practical implications for its members. The conservative nature of the 1972 paper may have been because the advisers were unwilling to give little indication of future growth points; neither design nor technology were much featured. The authors expressed the hope that, in conducting a 'reappraisal' of 'the teaching of handicraft, there will be a clarifica-

tion of objectives'. These turned out to be, in essence, a digest of the best of past practice with an infusion of ideas from recent official and Schools Council reports.

The following year, responding from pressure from a minority group to do something about design education, the association commissioned a second document, ultimately published as *Design in Craft Education* (1974).[62] Though the working party included Bernard Aylward and Joss Jocelyn, the Cheshire Adviser, both leading advocates of design education, the report lacked vitality. Again the authors would have been mindful of the fact that any recommendations had ramifications for Association members who espoused design education with varying degrees of enthusiasm. Such considerations had not inhibited the Association of Art Advisers, who in 1973 produced a well-thought out statement on design education.[63] Considering the overlap of interest between the two, any limitation of contact smacked of parochialism, a view reinforced by the limited sources of reference listed in *Design in Craft Education*.

Design in General Education

With the end of the Schools Council's project, the focus of design education research switched to the Royal College of Art. In the Spring of 1974 the DES funded an enquiry at the College into 'Design in General Education', under the direction of Professor Bruce Archer. For three years (1973-76) he and his team laboured to designate Design (with a capital D) as a third area of education. They boldly claimed for design discrete characteristics which separated it from the physical sciences and the humanities. This third area comprised

the collected body of practical knowledge based upon sensibility, invention, validation and implementation.[64]

The research team did not primarily set out to provide quantitative data detailing the extent of design education in secondary schools. Apart from recognizing the situation as being fluid, the RCA team knew itself to be 'an agency for change itself'. The RCA defined as the most important factors in the formulation and implementation of design education:

. . . firstly, the quality and motivation of the staff specialising in design-related subjects, secondly, the practical support given by the headteacher.[65]

The investigations predictably produced mixed responses. The majority complained that only a minimal amount of teaching material stemming from the two projects penetrated into the craft shops. This may well have been the case, but if literature was reportedly lacking, ideas derived from the two projects were not. Thus ILEA's Design and Technology advisory team under a staff inspector began an 'Innovation on Craft Education' which owed much to Keele.[66] London was not alone. However, the RCA researchers identified a lack of coordination between the Schools Council's projects which was frustrating to ordinary teachers as was the lack of effective support continuing after the research programmes ended. Project Technology (as a consequence of the Trent move) came out better in this respect.

Robert Clement, Adviser for Devon and Secretary of the Association of Art Advisers was one who disagreed with the Royal College that design is a subject like other areas in the curriculum: a defined area of knowledge and experience. Clement observed that, whilst a respectable body of theory relating to design had been built up as an abstract or problem-solving activity, 'that theory, being based on modes of activity external to the school, bears little relationship to the philosophies which contribute to design'.[67] This, and other points of fundamental concern were taken up by Anita Cross from the Design Discipline of the Open University, who subjected the Royal College's research to rigorous criticisms.[68] She asserted that:

> If Design then, is to be considered as basic to general education, it must be amenable to the usual meanings of basic or general education, i.e. an education which is, *in principle,* non-technical and non-vocational. It can only achieve parity with other disciplines therefore, by:
> (a) being organised as an area of study not unlike the Sciences and Humanities
> (b) providing instruction in concepts and methods of enquiry appropriate to life-long learning, and
> (c) attempting to foster an understanding and appreciation of the contribution that design activities and specialisms make to the individual's life and the lives of others.[69]
> In Education, interaction between three differing levels of activity is important for development and progress in a particular field. These levels of activity are conducted by:—
> 1. Scholars and researchers who develop ideas and provide the basic research.
> 2. Educationists who absorb, translate and suggest ways of utilising the basic research.
> 3. Teachers who apply and test methods and findings and provide feedback for further research.[70]

Anita Cross demonstrated that in comparison with what was available for mathematics and English teachers, there was virtually no carefully structured reference material written for teachers of design. Though she confined herself only to design education, her observations apply to all aspects of CDT teaching. 'Research' in CDT has overwhelmingly consisted of descriptive projects, their educational validity unquestioned and the structured learning stage involved almost totally ignored. The hard-pressed teacher may not find this a problem: when you have twenty pupils queueing up at the door, you want a range of projects that embody the new philosophy, not philosophy itself. It is their mentors who served them ill.

Nigel Cross, also of the Open University, stressed this need for fundamental research in his paper 'Designerly Ways of Knowing',[71] which sought to justify design's position as the 'third culture'. Though granting that '. . . there is still a long way to go before we can begin to have much sense of having achieved a real understanding of design as a discipline — we have only begun to make rough

maps of the territory', he identified five distinct aspects of 'designerly' ways of knowing.

1. Designers tackle 'ill-defined' problems.
2. Their mode of problem-solving is 'solution-focussed'.
3. Their mode of thinking is 'constructive'.
4. They use 'codes' that translate abstract requirements into concrete objects.
5. They use these codes to both 'read' and 'write' in object languages.

From these ways of knowing, Cross drew three main areas of justification for design in general education:

1. Design develops innate abilities in solving real world ill defined problems.
2. Design sustains cognitive development in the Piagetian sense in the concrete/iconic modes of cognition.
3. Design offers opportunities for development of a wide range of abilities in non-verbal thought and communication.[72]

Schools swept aside these and other theoretical considerations as the momentum for design education gathered pace.

Design Council support
Three reports from the Design Council supported the movement for design education. *Engineering Design Education* (1976) and *Industrial Design Education* (1977) were concerned with post-school professional design education, while *Design Education at Secondary Level,* claimed that 'design should be an essential part of the education of all children at all stages of secondary education up to the age of 16'.[73] Ideally this third report preferred the establishment of new departments 'dedicated specifically to the ideals of design education', but accepted as an alternative 'to enlarge the design area through subjects such as art, home economics and CDT'. Professor David Keith-Lucas's working party concluded with wide-ranging recommendations, suggesting that for their implementation:

A national body should be set up to bring together the many interests in design education and its application to life and work; and to co-ordinate the work that will be necessary for the effective furtherance of design education. The Design Council is probably the most appropriate organisation to provide the machinery for setting up and servicing this national body.[74]

That was in 1980. Things looked promising and by April 1982 the design promotion lobbyists had a seminar on design at 10 Downing Street. *The Designer* (the journal of the Society of Industrial Artists and Designers) commented

the occasion . . . will mark a turning point in the modern history of design in this country. We have devoted the whole of *The Designer* to a discussion of the important initiative taken by Mrs Thatcher in identifying design as one of the crucial areas of development in the regeneration of our industrial life, and instigating an enquiry into the steps that need to be taken.[75]

Mrs Thatcher's interest in design, nurtured by Lord Reilly, former chairman of the Design Council was again evident in two BBC programmes in June, 1985, where she described herself a 'design addict'. Further programmes featuring design have followed.

Influences both inside and outside the schools kept design education schemes in middle and secondary schools expanding throughout the seventies. Design faculties became the flavour of the decade; often, alas, a bland menu of wood-work, metalwork, art and home economics. Design educationists like John Hanrahan tried to show what the *haute cuisine* end of the market could do with the same ingredients.[76] The recipe was capable of being adapted, depending whether the background of the chef was from a CDT background — most common — or from art or even home economics. The last two offered a few opportunities for the promotion of women. No examples were found of science departments being integrated within a design faculty structure with a scientist as a head of faculty.

Tensions within design education

The wisdom began to be questioned of lumping subjects and departments together without appropriate bonds of understanding. From within CDT Francis Zanker bewailed the absence of a specific body of knowledge that could be identified with design education.[77] He rejected the idea that design education had a 'self proclaimed right' to subsume all matters of an environmental nature. From outside CDT circles, Colin Tipping of Middlesex Polytechnic attacked everything and everybody that moved, especially if they had college of education blood in their veins.[78] His scepticism that design education objectives stood little chance of being fulfilled with the existing composition of the teaching force was well founded. But his radical remedies however desirable, would have left design education in even worse disarray. Phil Roberts of the Design Education Unit at the Royal College of Art, in a critique of the Design Council's *Design Education at Secondary Level* criticised the relationship between CDT and its partners in design education, disputing CDT's assumption to the senior position, which the Keith-Lucas report appeared to support.[79] The bias detected by Roberts was unsurprising in view of the number of CDT experts on the committee. Roberts concluded that the identification of design with CDT had to be regarded as tendentious. Robert Clement concurred with efforts being made to bring different disciplines together but emphasized that the newly-formed departments lacked the homogeneity of traditional subject groupings as in the humanities, the sciences and languages:

> There has perhaps been too much emphasis with the Design Education movement . . . upon the establishment of a design rationale or process to which constituent subjects should *conform,* rather than seek for ways to rationalise and balance the different contexts within which the teaching of craft may take place.[80]

All this internecine fighting exasperated Ken Baynes, one of the founding fathers of design education. He lamented

> I want to look towards social and cultural aspects of design education and away from the debate about the content of the curriculum. I am disenchanted with it. It seems to me that it has rapidly become sterile. The irony is that an enterprise originally undertaken to bring together a variety of subjects has only resulted in even greater fragmentation. Like it or not, justified or not, the label 'design education' has become strongly identified with a particular way of grouping school subjects and the reform of content in teaching of woodwork and metalwork. Beyond that, progress is hopelessly embroiled in considerations of professional pride and the defence of established subject boundaries. The birth of a 'third area in the curriculum' looks in danger of being aborted because the midwives have resorted to punching one another on the nose.[81]

It is ironic that the publication of *Design Education at Secondary Level*, instead of launching a concerted drive for the wider dissemination of design education in the nation's schools, marked its high water mark. It is too early to write an obituary for design education. However, John Pilkington, who recently did a one year retraining course in CDT teaching, spoke for many of his colleagues in a sad epitaph in the *TES*:

> Coming from Goldsmiths' which could be said to be the original home of the design-based approach, I had not realised that an alternative approach even existed. The most damning sentence I heard was from an ex-Goldsmiths' graduate who said: "come from Goldsmiths' do you? Well, that approach went out 15 years ago".

Can the contributions of Goldsmiths' to CDT teaching in the 60s and 70s be so dismissed? Regrettably there are indications that design education's hey-day, if not past, is on the wane.

Educational links between design and craftmanship
This is not the place to assess the achievements and weaknesses of design education overall — but its influence on CDT has been considerable. Within the subject many were never more than luke-warm supporters of a well-rounded design education approach and opposed the CDT circus. Not for them the desperate effort to encapsulate all the world's problems — be they environmental, conservational or practical — at the expense of what most regarded as the kernel of their teaching: the end product. These CDT teachers appeared to be wedded to the idea of making, a rite performed in the workshops that surpassed all other activities. Design for them was quite specific: product design.

This presented difficulties. According to David Pye those with a craft training had the impression — he regarded it as an 'illusion' that 'every craftsman is a born designer'[83] Professor Pye believed that whilst 'there are no born designers',

it was possible to acquire the attributes of a designer slowly by much practice. Without wishing to argue for or against Pye's precept, it was one that many CDT teachers shared. Most are pragmatists at heart and aware of their strengths and limitations: craftsmanship on the credit side, design on the debit. They could see that when it came to designing — often equated with the presentation of ideas on paper — they often trailed behind their art colleagues. When it came to skill, that was different. Unfortunately, however, there were subversives in their own ranks. Because it was difficult to evaluate precisely the educational values stimulated and sustained by practical work — judgements being so subjective — critics tended to deny whatever could not be proved. Craftwork was disparaged as 'mere skill learning', consequently even those values inherent in 'mere skill' became discounted. This never happens to musicians. To raise this issue today is to risk being accused of educational ludditism. Too much was at stake to dispose of valued making activities for educationally seductive but unproven alternatives; essentially the view taken by HM Inspectorate in *Craft Design and Technology in Schools*.[84] Their examples of good design practice were restricted to linking designing with the making of an artefact, albeit by a variety of ways and means.

In the rush to devalue craftsmanship, the opportunity to capitalize on the educational advantages (previously recognised) of physically making something, were deliberately overlooked. A clearer distinction should have been made in school design between 'real' and 'abstract' design; the former suggests direct contact with things that could be made and the latter with the idea of things only. As Avigdor Cannon, the scourge of woolly CDT thinkers, used to tell his students:

> Since design implies a projected change of some sort, it would seem wise for the pupil to deal with change in circumstances and situations of which he can claim knowledge. All those changes in form, structure, articulation etc., which comprise a proposed design are made in response to the various controls of function, materials behaviour, fashioning appearance etc. Without an understanding of these factors, the rationality of design is lost and it becomes a series of happy accidents. Is it worthwhile, for instance, to set pupils to work on a motorway flyover, even with the preliminary study of traffic statistics? The knowledge of concrete structures, road form and so on are not likely to be available and the design produced under these conditions is therefore more akin to sculpture than to function. This may be an extreme case but it does go some way to point the weakness of abstract design.

Designing should be seen as a heuristic activity. It calls for a variety of skills — motor skills, communication skills, evaluation skills among them. At a fundamental level it has to do with thought and feeling. It involves both linear (logical) and lateral (creative) thinking. Design education has assisted CDT in making these more explicit. The nineteenth century women pioneers would sympathise with design educationists who feel they have been stripped of their ideas by the CDT lobby, and deserted. Latterly official encouragement has helped CDT to acquire educational respectability. This could prove superficial and short-lived. As Anita and Nigel Cross warned, the educational underpinning for establishing design

(the same could be said for CDT) as a third area of the curriculum, on the same footing as other subjects, has barely begun.

The drive towards technology

Despite the excellence of much of Project Technology's teaching material for CDT, many claim it was used in only a tiny minority of schools. Yet, of CDTs three components, technology has the appropriate depth of subject knowledge potentially to wrench CDT from its nineteenth century origins and make it a meaningful study for today's pupils, especially the academically more able. Its chances are not helped by the tensions between the scientists and some CDT factions.

Within CDT, there were identifiable growth points for technology teaching. The staff of the National Centre for School Technology at Trent Polytechnic, first under Professor Geoffrey Harrison and latterly, Geoffrey Shillitoe, struggled to get their message across to a wider cross-section of schools. In Bedfordshire, Ron Denny's technology bus brought technology to under-funded and under-staffed schools which individually could not afford it. Dr Ray Page and John Peele, at the Avon Science and Technology Centre, developed with west country teachers a modular course in technology then taken up by the School Technology Forum's Working Party on Curriculum and Examinations.[85] Following advice from the Schools Council's CAST Committee, the initiative was extended to incorporate Hertfordshire and West London authorities where teachers were pursuing similar curriculum objectives.

Elsewhere other enterprising developments could be cited but, overall, progress was quiet rather than spectacular. During the years 1975-78 HM Inspectors surveyed a record 384 secondary schools in England, and found that workshop activities, though listed in the index under CDT, were generally referred to throughout the text as 'craft' or more occasionally, as simply woodwork and metalwork.[86] The inspectors observed that most craft departments worked in isolation. A mere seven per cent of schools with GCE candidates made any effort to establish links between mathematics and CDT — an essential prerequisite, one would have thought, for the development of technology teaching.[87] And only three per cent of science departments made substantial use of Project Technology material. Eighty-six per cent regarded it as of 'little or no use'.[88] Craft continued to be identified with the less able pupil, academic high-flyers dropping it after the first two or three years.

At the same time as this HM survey, the Department published *Curriculum 11-16*.[89] Intended to stimulate professional discussion, in CDT circles it was greeted with mute, deferential respect — the new commandment, complete with explanatory text, received unquestioning obedience. The separation of technology from CDT passed almost unchallenged. The SCSST welcomed the report, obviously regarding technology as within its own province.[90] Similarly the Art Inspectors' submission, which incidentally sandwiched CDT between art and technology, delineated areas of overlap, devoting one section to the relationship between art and 'making' and 'inventing' activities. Design, in the design education sense, did not feature anywhere. Design in any capacity hardly fared better.

It appeared CDT had apparently been subsumed within the 'aesthetic and creative' areas of experience if one is to judge from the advice on constructing a common curriculum. Bob Doe in *The Times Educational Supplement* criticised the document as 'Vague, inconsistent, platitudious . . . of little help'.[91] At least his article contained some comfort for CDT in the photograph of a youngster with the steam engine he had conceived and made from scratch. The boy's headteacher saw this as 'the sort of confidence boosting work that can be achieved in years four and five if there is no rigid insistence on a common core'.

Not surprisingly, when the DES published *A Framework for the School Curriculum*, CDT failed to make the big time. It was not included in the proposed core curriculum, which consisted of English, mathematics, science, a foreign language, religious and physical education. However, in connection with preparation for adult and working life, the Inspectors embraced everyone in the field:

> Schools contribute to the preparation of young people for all aspects of adult life. This requires many additions to the core subjects in areas such as craft, design and technology; the arts, including music and drama, history and geography . . . moral education, health education . . .[92]

The reasons for CDT's exclusion from the core curriculum are not difficult to discover. Comprehensive schools, though vastly better equipped than many they replaced, usually continued to sustain within their structures the same stratifications of ability ranges. CDT foundation courses behind them, curriculum pressures deterred academically able children from continuing with practical subjects. The currency value of CDT examinations remained low. Within the inner sanctums of CDT, more time and energy was devoted to the impact of metrication, the implications of the Health and Safety at Work Act and the chronic teacher shortage than to curriculum development issues. Above all the majority of CDT teachers had neither the enthusiasm nor the expertise to teach technology, thus effectively limiting its development.

Reinforcement of education — CDT links

All this was to change in the aftermath of Prime Minister James Callaghan's 1976 Ruskin College speech. Was this the first step of an increasingly interventionalist and centralist DES or the gut reaction of a socialist prime minister that schools were failing children and the nation? Upon resigning from Parliament he declared the turn-around in our education system to be one of his proudest achievements. CDT was at centre stage in the 1976 'Green Paper' which recommended that:

> More attention should be given in initial teacher training to the national importance of industry and commerce, to helping them (the prospective teachers) in their responsibility for conveying this to their pupils.[93]

Sir James Hamilton, DES Permanent Secretary stressed the necessity of closer education-industry links in his speeches. Addressing the SCSST in April 1979, he professed still to favour the idea of a protected core curriculum but it did not include CDT. Sir James was speaking about the relationship between manpower

planning and education.[94] He agreed that forecasting had 'not been good' in the past, but said that the atmosphere 'is now better than it has ever been for moving ahead on this front'. Dr A.J. Pope, then Vice Chancellor of Aston University in a talk to the School Technology Forum,[95] said he was amazed that more youngsters were not queueing up to study engineering, seeing that 'the whole of the toy industry is biased towards engineering and technology'. The question, according to Dr Pope was not 'how do we turn on more able young people to science and technology?' but rather 'what is there in the educational system that turns them off?'

When Sir James returned to address the Standing Conference on 'Perspectives and Priorities'[96] Margaret Thatcher had become Prime Minister. Education-industry links continued to be given high priority, reinforced in HMSO publications. Speaking of *The School Curriculum,* Sir James was critical of the 'tortuous discussions' that preceded attempts to reform the curriculum, but which it seemed impossible to circumvent.

Though he was encouraged to hear that:

> from all the evidence, the business of links between schools and industry is booming and will continue to boom',

Sir James expressed a 'very personal view' that he did not believe

> that we have in the school curriculum moved as far and as fast as we could towards what I might call a pre-vocational approach to the education of 14-16 year olds. Now let me make it clear that when I talk about pre-vocational education I am not asking for a system that produces ready-made fitters or welders at 16. That way lies disillusionment of a very high order. Nor am I talking about the process of putting those people who have been turned off by conventional approaches to education, on to tinkering with aged motor cars just to keep them out of mischief. What I have in mind is an approach that, without yielding an inch on rigour, recognizes the need for some young people to learn from doing, through practice, through action, rather than by more the conventional academic canons which had dominated school education for so long.[97]

The dust-gathering Crowther Report had not been entirely forgotten.

Sir Alex Smith, then Director of Manchester Polytechnic, did not mince his words at the 1980 Stanley Lecture at the Royal Society of Arts:

> We are at a crisis now in our history. I call it a crisis, but even that is too bland a word to describe our condition. A crisis has about it the nature of an emergency which can be corrected by emergency measures. What we are experiencing is properly called a climacteric, a prolonged period of steady decline which needs much more profound measures to correct it. It is a less common word, however, and so I will continue to call our predicament a crisis. The crisis is one of our capacity, our ability to earn a living amongst the community of nations.[98]

On another occasion, Sir Alex criticised the Finniston Report for not effecting change in the school curriculum, recommending that:

> Every child in every school, every year, should be required to design something and make it . . . Education through designing and making is a basic need, even if our industries were blazingly successful, which they are manifestly not.[99]

Mrs Thatcher became an effective proselytizer for design. She presented the prizes to the winners of the Design Council's annual Schools Design Competition, so drawing the attention of the national media. The annual design competition cannot, however, be seen as a reliable measure of the health of design activities in the nation's schools. At the time entries ranged between 200-300. Fewer still entered for the Young Engineer for Britain competition — from over 5000 schools. Latterly the number of entries for the design competition has risen, especially from art departments.

Newspapers — popular and quality — now regularly carried articles on education — industry links. *The Times,* for example, reported the visit of sixteen senior industrialists to King Edward VI Comprehensive School in Northumberland,[100] and their view that children should 'have a broad education and be able to analyse problems and express themselves'.

Under the aegis of the SCSST, Sir Denis Rooke, Chairman of British Gas, gave a lecture on the topic of 'Education and national economic effectiveness',[101] in which he challenged how effectively education could respond to industry's needs:

> Education is certainly changing now in response to external pressures, but will it ever be able to change fast enough to reflect the vocational needs of each cohort of future students? Would attempts at early specialization be any more successful in matching the output of our schools and universities with needs in the future than it has been in the past? I believe that the answer to these questions is 'Emphatically No!' And yet clearly we have to improve the system.

Certain solutions he considered well intentioned but somewhat simplistic. He singled out TVEI

> The controversial Technical and Vocational Initiative is a brave experiment introducing a vocational element into education at an early age as low as 14. It is intended that this should improve 'relevant and transferable skills'; and be about helping students 'learn to learn!' But at this age who makes the selection? While endorsing what I understand to be many of the principles involved, yet I would urge caution. Can we be sure that youngsters specialising in a technical and vocational course are those who might ultimately be the most suitable for craft, or technical training? More importantly, will it provide a source of future innovators, as distinct from technicians? While the first industrial revolution was led by men of practical skill, the foundation of knowledge and experience required for innovation today is now both considerably higher and broader.

137

Vocational initiatives

Few in the CDT fraternity have any such reservations, yet it is not impossible that this road could take the subject right back to where it started a century ago. The purpose behind TVEI is essentially to provide industry with skilled workers, as they understand 'skills'. White coats may have replaced the dungarees of the nineteenth century, but the destination is the same and again the edges between education and training are being blurred. Lord Young in the *Times* dismissed the division between the two as 'sterile', arguing that he trained as an accountant, as do some architects, surgeons and so forth.[102] But to equate the training of professional people in their twenties with youngsters in their formative years is hardly to compare like with like. Moreover, as John Mann, former secretary of the Schools Council pointed out in the Joseph Payne Memorial lecture:

> Vocationalism may be an appropriate response to an immediate crisis but as Donald Schon observed, 'A man who defines himself as a chemical engineer, a shoemaker or a specialist in internal medicines, runs in increasing risk of building his identity on an unstable base'.[103]

As already seen, most CDT teachers until recently believed firmly in teaching their subject for educational and not vocational reasons. It is time to reopen these old Victorian files and refresh memories. Headmasters who valued manual instruction at the time still believed their charges to be better served by continuing with a broad general education that would enhance not limit eventual career choices.

Secretarial courses for girls are a good example of vocational training at secondary level. A high percentage of their teachers had commercial experience incidentally. Taught correctly, secretarial subjects can have much educational as well as vocational validity, yet how many academically able girls were encouraged to pursue these courses, courses which led to an employment stratification from which few escaped? Wage rates may have been relatively high and working conditions pleasant but too many able women ended up employed in propping up male bosses. The pattern of secretarial wage levels has implications for the wider introduction of vocational training within CDT. When word processors came in, women with word processing skills at first commanded high rates. As the supply increased, rates fell. There has always been an element of vocational preparation within CDT and the popular image of workshop subjects always had hazy associations with industrial employment. Craft teachers, especially those with industrial experience, often ran courses geared to employment in local industry, helped by the Associated Examining Board's Engineering Workshop Theory and Practice examination. Similarly, booming City and Guilds foundation courses gave some indication of the size of the market that could be tapped.[104] The vocational nature of these courses most attracted pupils: disenchanted youngsters were regularly reported to be working with 'enthusiasm' and 'motivation'. Despite this, these examinations were cold-shouldered by the CDT establishment, whose own efforts to reform practical subject examinations took an entirely different route. It was feared that early specialization might restrict general education opportunities. Some teachers

were reported to be 'angry' at the City and Guilds Institute for acting opportunistically and so threaten the success of some of the more broadly based GCE and CSE examinations. The Institute replied that new vocational courses were developed solely in response to demand from schools and colleges.

The Engineering Industry Training Board — a cautionary tale

The pitfalls of gearing school courses too closely to the needs of industry are encapsulated in CDT's dealing with the Engineering Industry Training Boards' proposals to reform apprentice training. Its research document *School Learning and Training* was enthusiastically received in CDT circles. The Boards' findings revealed

> . . . trainees who had taken craft subjects at school tended to perform better in training than those who had not, even though at the start of training the people who had taken craft subjects did no better in the test of intelligence, arithmetic, spatial ability and planning skill. This finding accords with the general opinion of instructors, who mostly prefer craft trainees who have some experience of craft subjects. The finding that technicians who had taken craft subjects tended to get a better assessment in their training than those who had not was less to be expected. It does, however, highlight the importance of experience of practical subjects for all school pupils, not just those regarded as academically 'less able'. It can indeed be argued that practical work should be part of any balanced curriculum[106]

Subject specialists preened themselves upon learning that apprentices with a craft background out-performed those who had taken science in respect of 'planning skills'. Ironically no one commented that aprentices in the sample would generally have taken traditional metalwork examinations — precisely the type the CDT hierarchy was busily trying to demolish! However, the love affair between CDT and the Engineering Board grew stronger.

Bench and machine skills, the Board proposed, should be taught in the schools, not by industry.[106] Its proposals were hailed as an historic contribution to craft education. The Minister of Education, Shirley Williams, greeted them with enthusiasm, but she and the Board had miscalculated and the CDT establishment even more so. Traditional craft teachers remained the only loyal suitors. The relationship faltered and was replaced by a modular system. Trainees who had completed an appropriate technical/practical option at school were to be given special dispensation that would speed their basic training course.[107]

Hardly had the print dried on the Engineering Board's modular course than apprentice recruitment fell to crisis levels as manufacturing output collapsed. One can imagine what would have happened to the 'enthusiasm' and 'motivation' of youngsters in the fourth and fifth forms had school courses been more closely tied in with industry. In 1984 — only three years after the introduction of the modular course — the Engineering Training Board decided to change the whole basis of its training courses to meet the new technological skills demanded by

engineering and electronic firms. Where would it have left schools that had geared themselves to meet Board requirements? This is probably not an isolated episode in education-industrial co-operation. As the pace of technology quickens how can schools — desperately short of staff and resources — continually adjust to the changing demands of industry?

Education — industry links

Links between education and industry forged by James Callaghan, tooled-up by Sir Keith Joseph at the DES were given a cutting edge by Lord Young at the Department of Industry. Sir Keith, unlike Lord Young made a clear distinction between education and training — at least in the upper echelons:

> It is not the role of school education to prepare children for a particular job. Even in an obvious case where children make vocational choices — medicine for example — they still need to develop their potential outside their job.[108]

Lord Young was for many years associated with the work of ORT, the Jewish Organisation for Rehabilitation through Training and has been influenced by its philosophy.[109] ORT, the largest independent technical and vocational education organisation in the world is responsible for more than 10,000 students in schools, training centres and projects in 27 countries. The charity, founded in 1880 at St Petersburgh in Russia set out to teach Jews wage-earning, transportable skills so that they could escape from the poverty in which they were living and the countries that oppressed them. The connection between education and the ability to earn a living is part of a long Jewish tradition; even philosophers like Leibniz had a trade as a lens grinder. We have recorded that the Swedish philanthropist Gustaff Abrahamsson bequeathed his estate to enable his nephew Otto Salomon to develop his work in practical education and the two foremost protagonists of technical education in nineteenth century Britain — Sir Bernard Samuelson and Sir Philip Magnus — were both prominent Jews. The Technical and Vocational Education Initiative today owes much to ORT. Ministers were briefed by the organisation before TVEI was announced, and later, the House Select Committee visited an ORT school at Lyon, in France. Many of the original TVEI schemes turned to ORT for advice and information. Even accepting that ORT is no longer pre-occupied with the teaching of manual skills — its computer and robotics centre is located in London — it is still a questionable vocational basis from which to lead Britain into the twenty-first century.

Any such reservation was swept away in the haste to implement TVEI policy. Funded by the Department of Industry, not the DES, this radical departure from British tradition initially met with fierce resistance from many quarters. Though critics remain, LEAs were desperately short of cash and found the bait of funding on an unprecedented scale irresistible. The scheme, specifically intended to stimulate the development of technical and vocational education for young people between the ages of 14 and 18, took off. In 1983 the MSC generally allocated money for premises, equipment and consumables and such items as residential education and additional staffing. The latter stood out as the single most impor-

tant item of expenditure, over 60 per cent of available resources being allocated for this purpose. Each LEA was expected to develop proposals to help its teachers to equip and adapt themselves to meet the changing needs of students within the project.[110]

The intention to evaluate the work of fourteen initial centres before proceeding further was dropped. Forty-three more LEAs joined the first fourteen in September 1984; twenty-four more in 1985, and another twenty-eight in Autumn 1986. Originally it was expected that about three per cent of students in the relevant age group, and eight per cent of secondary schools would be involved. TVEI planners claimed that the scheme would involve both boys and girls from across the whole ability range.

The scope of the scheme is, of course, far wider than the boundaries of CDT. However, no other subject is likely to be so directly and indirectly affected. The evaluation being carried out is not complete, but preliminary findings substantiate reservations expressed when TVEI was launched. The Leeds evaluation team have studied twelve schemes in depth and found that technology was taught outside the confines of CDT, most often within a science context and in theory lessons of an applied science nature. The approach appeared fragmented: 'A bit of electronics and a bit of mechanics'. The researchers noted that the design process as taught was seldom related to the real world and that most teachers used a very restricted range of technological examples despite the huge variety available. More surprisingly the team found little evidence of industrial or commercial realism in the way the work was being tackled and virtually no discussion on the moral and social values related to technology.

Many within CDT see TVEI as effective and a further step towards wider subject recognition, and ignore any possible long term consequences. Young people interviewed in public relations exercises are made to feel special and respond accordingly and local employers make approving noises. At long last schools are turning out students geared to the needs of industry. Prospects that MSC pump-priming operations will result in an enhancement of CDT teaching in the mass of schools should be treated with caution. The same results cannot be expected from schools without the same level of funding, resources and staffing. By offering enhanced salaries and promotion opportunities TVEI is attracting some of the best qualified and most experienced CDT teachers who may leave vacancies behind them. Though MSC money is available for various initial teacher education programmes, not many new applications have been made. Without enlarging the pool of skilled teachers, local TVEI successes can be achieved only at the expense of the rest of system.

Professor Pring in the 1986 Stanley Lecture examined TVEI against a broader backcloth of vocational training, after hundreds of hours of interviews.[111] Students were generally satisfied with their courses and liked the practical aspects, 'the more relaxed relation between student and teacher, the greater responsibility for own learning and the use of modern technology'. Professor Pring did, however, identify a number of major areas of friction:

First, the more practical, assignment-led group work ill-fits an examination system whose national criteria allow little scope for these characteristics . . . Secondly, a full-time four year course is incompatible with progression to a YTS scheme at 16 — and yet that is what is necessary if the students wish to enter into certain kinds of employment — catering, hairdressing, construction, engineering. Thirdly, there are mixed reports about the ability range. Unless we are careful, the scheme could become the basis of a vocationally divided system — at 14 the academic, single subject route into higher education and the professions for the better motivated or more able, and the vocationally oriented skills-based and practical route for the rest. Already in one local authority a paper is circulating for selection of the majority at 14 for a vocational, as opposed to an academic, education.

HM Inspectorate in its *Technology in Schools,* did not gloss over the difficulties confronting technology teaching inside CDT departments (and did not even refer to technology teaching in science departments).[112] The inspectors described the work of 90 schools in England and Wales, roughly 10 per cent of all the schools running technology courses in 1981, of whatever standard. In answer to the question 'Why is technology in the curriculum?' the Inspectorate surprisingly did not even mention political pressures. By far the most important influence, they found, was that of the LEA adviser — almost always the CDT adviser. In a few cases, teachers complained that advisers 'were encouraging a move towards technology too hastily and that technology was included because it was seen as a "bandwagon" '. Whether teachers saw the Inspectors themselves as agents of change is not recorded. Some teachers mentioned being influenced by activities of the National Centre for School Technology; a few by their local SATRO.

A high proportion of the schools selected by HMI restricted technology teaching to pupils from the higher ability ranges. This must account for much of the more enterprising work currently going on. However, the author has more than once heard teachers having that confidence built with the advice: 'You don't need to worry about them, they'll teach themselves'. Hardly the advice that language, maths, English or physics teachers would receive. Technology needs to be taught within a rigorous framework — different from traditional academic subjects, but no less demanding. Looking at the background of those teaching technology, the inspectorate found a significant proportion from industry, largely with mechanical engineering experience, which helps to explain the popularity of structures and mechanism components in CDT examinations. These teachers, though doing an excellent job themselves had reservations about their ability to cope with new technologies, reservations which have nevertheless been frequently ignored.

The key question remains, 'Will TVEI and technology teaching undertaken within CDT departments contribute significantly to resolving Britain's chronic skill shortage and provide a reservoir of ability to tackle new problems in the years ahead?' Even with up to three million unemployed, employers are complaining that production is curtailed because skilled workers are in short supply. *Attitudes Towards Employment*, a Gallop Survey conducted for the CBI, quantified

the shortfall.[113] 'Please specify below the types of jobs with which you are having recruitment difficulties?', elicited the following occupations:

		% of total number
Engineering	214	30
Skilled Manual	168	21
Management	77	10
Financial Services	43	6
Sales and Marketing	68	9
Computer Programmers & Systems Analysts	70	9
Draughtsmen	11	1
Technicians	21	3
Clerical Staff	17	2
Data Processing	15	2
Surveyors	8	1
Supervisors	6	0
Other	37	5
Total	765	100

The *CBI News* commented:

'. . . the survey also reveals how skill shortages are causing increasing difficulties. Three out of five employers are having difficulty in filling jobs requiring skill, qualifications or experience. Such difficulties are restricting output for about one-in-five of all firms'.[114]

The survey detailed many hundreds of skilled occupations within the broad categories listed for which CBI members wished to recruit. Yet eighteen months later, in April 1987, the CBI announced its most optimistic industrial forecast for ten years. Lack of skilled workers appeared to have been less of a drag on inceasing productivity than the earlier survey feared. The missing workers could not have been trained in that time so the disparity between the two surveys raises questions about both accuracy and interpretation. Perhaps pre-election fever had something to do with it. Another factor might be that industry still relies heavily on employing workers to operate low level, simply operated machinery and equipment, as the study for the National Institute of Economic and Social Research demonstrates.[115] Stephen Davies and Richard Caves showed that Britain's eight top performing industries were, on average, 40 per cent below the American level of productivity and our eight lowest performers 75 per cent below. The vast difference between the two economies says more about the quality of management in Britain and America than about the availability of skilled workers. Professor Charles Handy's report for the National Economic Development Office exposes the poor qualifications of managers in the UK.[116] Many lack the expertise they need to make basic decisions of a high-tech nature on which Britain's future industrial competitiveness will depend. The inadequate technological expertise of managers also exacerbated the appaling level of industrial training. With a few distinguished exceptions such as Jaguar, British Gas and Lucas, British manufac-

turers do not invest in training on the scale of our industrial competitors. Some attack the education system, like their nineteenth century counterparts, to disguise their own lack of planning. Even if the schools were to involve themselves in training, they could never hope to satisfy industry's often vague and unquantified needs. Brian Nicholson, chairman of the Manpower Services Commission, whilst corroborating the gravity of the skill shortage, revealed that the MSC lacked 'comprehensive information about the local skill needs and available training courses' and had no 'inventory of skills possessed by the workforce'.[117]

It may be objected that this is not the issue. Echoing Sir Philip Magnus, today's advocates also oppose specific job training and place their faith in the teaching of generic transferable skills. To what extent the skills taught are transferable remains largely unquestioned. We have noted scant transferability between woodworking and metalworking skills and technology. The gap between what is being taught today and what industry will require in ten years time is likely to be immense. The introduction of a skill training element into the secondary curriculum may even inhibit the ability of a worker to retrain later in his career. To quote Professor Pring again:

> First what constitutes a basic or generic skill is very confused. But secondly, and more dangerously, the whole skills-based approach to the curriculum development represents a shift away from the curriculum as a set of transactions between teacher and taught, responding to the student needs as teachers sensitively identify them, towards a more mechanical and externally controlled conception of what the curriculum is about.[118]

The MSC's industrial training programme mirrors that of West Germany. The massive programme of vocational education has served the Germans well over the last forty years. Fears are now being expressed that it may no longer continue to do so. Might it not be wiser to look towards the American or Japanese pattern? Britain's problem in 1987 echoes that faced by the Japanese in 1956 when the Japanese Federation of Employers' Associations (the equivalent of the CBI) complained that:

> Japan carried out a reform of the school system after the war, but little attention was paid to the importance of technical education. At universities, the custom of placing too great an importance on law and the liberal arts compared with natural science and engineering had not yet been rectified, while the effort to promote scientific and vocational education in the course of compulsory education is still far from satisfactory. Unless plans to foster technicians and skilled workers parallel to the epochal growth of the Japanese economy are mapped out in order to ensure the enhancement of industrial technology, Japan's science and technology will certainly lag behind the constantly rising standards of the world and the nation will turn out a loser in international competition, putting the next generation of Japanese people at a great disadvantage.[119]

Reforms then instituted provided the base for Japan's success over the last decades. The Japanese took a stand against early specialisation and did not introduce technology into the schools. No curriculum document makes any reference to technology for children under the age of sixteen, but 'Industrial Arts and Homemaking' has a distinctly familiar ring:

Woodworking

Objectives
1. To make students understand the relationship between the properties of wood and ways of working through the design and production activities of simple wood products, and to develop an ability to produce accordingly with the objective of production.
2. To make students understand the relationship between load, material and structure through the design and production activities of wood products, and to enhance an ability to produce accordingly with the purpose and condition of usage.[120]

Students in Japan are required to do simple designing and make articles employing traditional constructions using hand tools. The criteria for metalwork are identical to that for wood. But in the Upper Secondary Schools (16 plus) the scientific and technological orientation is striking. One curriculum guideline states that:

. . . proper guidance should be given, in conformity with the realities of the school and its region, to provide the students with work experience so that students may appreciate the pleasure of working and creation, and develop a desirable view of work as well as occupation.[121]

The section devoted to industry is all-encompassing. The various MSC initiatives, CVPE, 'A' levels, BEC and TEC courses and qualifications available to British students of the same age as the Japanese look very small beer in comparison. And it is not as if the Japanese and our other competitors are standing still. The French thrust towards technology teaching is making our own effort look trifling. But, serious as our shortfall of skilled workers is, its importance as a crucial factor in our decline as a manufacturing nation should not be overestimated. The fundamental problem lies elsewhere, and was exposed by Sir Monty Finniston, at the Beethoven Street Centenary Celebration lectures, when he said that a survey examining the growth points in the Japanese economy since 1946 had shown that over fifty per cent were of British origin. This unhappy tale of missed opportunities can be endlessly repeated. This richness and diversity in the field of invention in Britain sprang from an education system encompassing State schools — elementary to comprehensive — and the independent sector. The simplistic philosophy which blames our economic ills on the failure of schools to contribute to vocational training must be challenged. How many ideas originating in Britain have ended up being manufactured abroad primarily because of a shortage of or a failure on the part of skilled workers?

They left these shores more because of an absence of the entrepreneurial spirit and because too many companies — dominated by myopic accountants — were more concerned with avoiding loss than spotting winners. Investment in the manufacturing industry remains low. Britain's multi-million pound training budget is only one facet of a wider problem which is still not being fully addressed.

References

1. School Board for London *Report of the Joint Committee on Manual Training on the Development of Work in Connection with Manual Training* (5th December 1898), 1-24.
2. Board of Education *Handbook of Suggestions for Teachers* (1944), 256, HMSO
3. see The Crowther Report (1959), HMSO.
4. L. Lambourne *Utopian Craftsman The Arts and Craft Movement from the Cotswolds to Chicago* (1980), Astrogal. M. Comino *Gimson and the Barnsleys* (1980), Evans.
5. Institute of Contemporary Arts *William Morris Today* (1984). A. Dyson Exhibition Review: William Morris Today *Journal of Art and Design Education* 3 No. 2 (1984), 217.
6. William Morris *How We Live and How We Might Live* (1888). Quoted William Morris Today.
7. Ministry of Education *Metalwork in Secondary Schools* (1952). Third impression 1959.
8. *Ibid.,* 30.
9. S.H. Glenister *The Technique of Handicraft Teaching* (1953), 88-98.
10. S.H. Glenister *Contemporary Design in Woodwork* (1955). S.H. Glenister with B. Larkman *Contemporary Design in Metalwork* (1963), John Murray.
11. Ministry of Education *15-18* (The Crowther Report), (1959), HMSO.
12. *Ibid.,* 392.
13. National Centre for School Technology, W.S. Brace 'Profile: Edward Semper' *School Technology* (6th March 1973), 7; Schools Council *Field Report No. 3* (1965).
14. 'Doncaster Technical High School — A Pictorial Survey' (May 1959), 23-25.
15. Institute of Mechanical Engineers, G.T. Page *Engineering Among the Schools* (The Page Report), (1969), IME.
16. *Ibid.,* 161.
17. G. Sommerhoff *Creative Technology at Sevenoaks School* (1979).
18. G.M. McCulloch, E. Jenkins and D. Layton *Technological Revolution? The Politics of School Science and Technology in England and Wales since 1945.* 2 (1985), 128, Falmer.
19. G. Sommerhoff 'The Technical Activities Centre' in L.C. Taylor (Ed.) *Experiments in Education at Sevenoaks* (1965), 57-72, Constable.
20. G. McCulloch, E. Jenkins and D. Layton *Technological Revolution?* (1985), Falmer, 128. See also Schools Council Project Technology, G.T. Sneed 'Applied Science at Baling' *Bulletin 4* (July 1968), 74.
21. G. McCulloch, E. Jenkins and D. Layton *Technological Revolution?* (1985), 151, Falmer.
22. *Ibid.*
23. *Ibid.,* 131.
24. Schools Council, D.I.R. Porter *A School Approach to Technology* (1967), HMSO
25. G.M. McCulloch, E. Jenkins and D. Layton *Technological Revolution?* (1985), 132, Falmer.
26. Schools Council *Technology and the Schools Project Technology Pilot Study Report* (November 1967), 6.
27. G.B. Harrison, letter to *The Times Educational Supplement* (21 May 1965).
28. H.M. Pemberton to Sir Cyril Hinshelwood, (16 March 1967) (Hartley papers Box 229) in G. McCulloch, E. Jenkins and D. Layton *Technological Revolution?* (1985), 153, Falmer.
29. *Ibid.,* 159-160.
30. *Ibid.,* 171. Professor K. Keohane to Lord Jackson (31 January 1968) (Jackson papers, file FH7).
31. *Ibid.,* 171. D.W. Harlow to Sir H. Hartley (29 January 1968) (Jackson papers, file FA/2).
32. *Ibid.,* 180. G. Cockerill to Sir F. Mason (15 October 1971) 180 (SCSST papers). See also Schools Council Project Technology *The Next Two Years* 1970-1972 (1970), Schools Council.

33. Schools Council Research Studies, D. Tawney 'Project Technology' *Evaluation in Curriculum Development: Twelve Case Studies* (1973) Macmillan, 159-176. See also Schools Council Project Technology 'The Evaluation of Project Technology' *Bulletin 12* (January 1970), 6.
34. Ministry of Education *Half Our Future* (1963) (The Newsom Report), HMSO.
35. *Ibid.,* 33.
36. *Ibid.,* 130.
37. Schools Council Research and Development Project in Handicraft *Survey 3* (December 1969), 3.
38. Schools Council Art and Craft Education 8-13. See report *Children's Growth through Creative Experience Art and Craft Education 8-13* (1974), Van Nostrand Reinhold.
39. Schools Council Working Paper 26 *Education through the use of materials: the possible role of school workshops in the education of secondary-school pupils* (1969), Evans.
40. *Ibid.,* 37.
41. P. Garner *Contemporary Decorative Arts from 1940 to the Present Day* (1980), 23.
42. M. Tyson 'Creativity' in B.M. Foss *New Horizons in Psychology* (1966), 167-182, Penguin.
43. L. Hudson *Contrary Imaginations* (1966).
44. Council of Industrial Design 'A combined approach to design education in schools' *Design* (August 1966).
45. *Ibid.,* K. &. K. Baynes 'Classroom consumers/the moulding of a design public' (January 1967), 15. 'Teaching the teachers/educating for an industrial society' (March 1967).
46. National Union of Teachers *Design in Education Conference Report* (19 February 1969), NUT.
47. *Ibid.,* 5.
48. M. de Sausmarez *Basic Design: the dynamics of visual form* (1964), Reinhold.
49. K. Rowland *The Development of Shape* (1963); *Pattern and Shape* (1964), Ginn.
50. J.G. Gosling 'Design Text Books' *Practical Education* 68 (October 1970), 24.
51. F. Zanker *Design and Craft in Education* (1971), Dryad.
52. Royal Academy of Arts *Bauhaus* (1968), Royal Academy of Arts.
53. D. Pye *The Nature of Design* (1964), 65, Studio Vista.
54. K. Baynes (Ed.) *Attitudes to Design Education* (1969), Lund Humphries.
55. P. Green *Design Education* (1974), Batsford.
56. B. Aylward (Ed.) *Design Education in Schools* (1973), Evans.
57. *Studies in Design Education and Craft* 6 (Spring 1974), 3.
58. Schools Council *Materials and Design: A Fresh Approach* (1974). *Design for Today* (1974). *You are a Designer* (1974). *Education Through Design and Craft* (1975), Edward Arnold.
59. S.J. Eggleston, 'The Transformation in Design Education: an analysis of the Keele Project' *Studies in Design Education and Craft* 7 (Spring 1975), 49.
60. S.J. Eggleston *Developments in Design Education* (1976), Open Books.
61. Association of Advisers in Design and Technical Studies *Craft Education* (1972).
62. Association of Advisers in Design and Technical Studies *Design in Craft Education* (1974), Association of Advisers in Design and Technical Studies.
63. Association of Art Advisers, The Establishment of Design Departments in Schools *Statement* (June 1973).
64. Royal College of Art, 'The Three R's' *Design in General Education* (1979), 14, Royal College of Art.
65. *Ibid.,* 31.
66. Inner London Education Authority, R.T. Noot, 'Innovation in Craft Education' *Craft and Technical Studies Journal* (Summer 1973), 1.
67. Royal College of Art *Summer School Report* (1976), 19.
68. A. Cross, *Design in General Education — a comparative introductory review* (November 1978), Open University.
69. *Ibid.,* 4.
70. *Ibid.,* 4.
71. N. Cross, 'Designerly Ways of Knowing' *Design Education Research Note* (1982), Open University.
72. *Ibid.,* 17.

73. Design Council *Design Education at Secondary Level* (1978), 5, Design Council.
74. *Ibid.,* 19.
75. Society of Industrial Artists and Designers *Designer* (April 1982).
76. J. Harahan *Design in General Education* (1978), Design Council.
77. F. Zanker, 'Design Education — A Change in Name Only?' *Studies in Design Education and Craft* 8 (Winter 1975/6), 27.
78. C.C. Tipping 'The Design Education Myth' *Ibid.,* 12 (Autumn 1979), 111.
79. National Association for Design Education, P. Roberts, 'A contribution to the development of design curriculum studies:. a critique of the Design Council's Report, *Design Education at Secondary Level' NADE Journal* (Spring 1981).
80. R. Clement, 'Developing Craft Activities in Schools' *Journal of Art and Design Education* 3 (November 1984), 291.
81. K. Baynes, 'Beyond Design Education' *Journal of Art and Design Education* 1 (November 1982), 106.
82. J. Pilkington, 'Retraining . . . one year on' *The Times Educational Supplement* (18 October 1985), 41.
83. D. Pye *The Nature and Art of Workmanship* (1968), 64, Cambridge University Press.
84. DES *Craft, Design and Technology in Schools — some successful examples* (1980), 30, HMSO.
85. R. Page, 'A Modular O Level/CSE Course in Technology' *Studies in Design Education Craft and Technology* 10 (Spring 1978), 91.
86. Department of Education and Science *Aspects of secondary education in England* (1979), HMSO.
87. *Ibid.,* 148.
88. *Ibid.,* 205.
89. DES *Curriculum 11-16 Working papers by H.M. Inspectorate: a contribution to the current debate* (1977).
90. SCSST 'A *Framework for the School Curriculum' Response by SCSST* (1977).
91. *The Times Educational Supplement* (23 June 1978), 6.
92. DES *A Framework for the School Curriculum* (1980), DES.
93. DES *Education in Schools: A Consultative Document* (1977), HMSO.
94. SCSST, J. Hamilton, 'Trends in Education for an Industrialised Society' *Keynote Address* Ninth annual meeting of the Standing Conference on Schools' Science and Technology (23 April 1979).
95. SCSST, J.A. Pope, 'Technical manpower needs of industry', Conference Technology: A Curricular Dilemma School Technology Forum *Working Paper No. 4* (17 March 1979), 11.
96. Standing Conference on Schools' Science and Technology Conference 'The Contribution of Education to Economic Recovery'. J. Hamilton *Perspectives and priorities* (18 November 1981).
97. *Ibid.,* 8.
98. A. Smith, 'A Coherent Set of Decisions' *The Stanley Lecture* (22 October 1980), Stanley Tools.
99. A. Smith, 'Uprooting the dead ideas' *The Times Educational Supplement* (11 April 1980), 4.
100. 'Top businessmen tell teachers what industry wants' *The Times* (10 November 1983), 3.
101. British Gas, D. Rooke, 'Educational Investment in Human Assets' *The Standing Conference on School Science and Technology Annual Lecture for 1984* (1984).
102. 'Maths + Metalwork = Motivation' *The Times* (4 December 1985).
103. *Education* (1 November 1985), 385. *The Times Educational Supplement* (8 November 1985), 10.
104. 'Booming C & G courses alarm the exam boards' 'Foundations for a life?' *The Times Educational Supplement* (13 October 1978), 5; (24 November 1978), 12.
105. Engineering Industry Training Board *School Learning and Training* (1977), 9-10, EITB.
106. EITB *Review of craft apprenticeship in engineering* (1978), EITB.
107. EITB *The Training of Engineering Craftsmen* (1981).

108. *The Observer* (16 June 1985).
109. 'Preparing for the real world outside' *The Guardian* (23 November 1982). D. Hofkins 'ORT: confidence through skills *Education* (3 February 1984).
110. Manpower Services Commission *TVEI Review 1984* (June 1984).
111. R.A. Pring, 'The curriculum and the new vocationalism' *The Stanley Lecture* (October 1986), Stanley Tools.
112. DES *Technology in Schools* (1982), DES.
113. Confederation of British Industry 'Attitudes Towards Employment' *A Survey of Employers, Employees and the Unemployed Conducted by Gallop for the Confederation of British Industry* (November 1985).
114. CBI, 'Skill shortage worsens but job hopes grow' *CBI News* (22 November 1985).
115. R. Caves and S. Davies *Study based on British and American Industries 1966-67* (1987).
116. National Economic Development Council/Manpower Services Commission/British Institute of Management, C. Hardy *The Making of Managers Report of Management, Education, Training and Development in the USA with Germany, France, Japan and the UK* (April 1987).
117. *The Observer* R. Taylor, 'Britain's skills scandal (22 February 1987).
118. R.A. Pring, 'The curriculum and the new vocationalism' *The Stanley Lecture* (October 1986), Stanley Tools.
119. Cited in M. Aso and I. Amano *Education and Japan's Modernization* (1983), 79, Japan Times.
120. Educational and Cultural Exchange Division UNESCO and International Affairs Department Science and International Affairs Bureau Ministry of Education, Science and Culture Government of Japan. *Course of Study for Lower Secondary Schools in Japan* (1983), 85.
121. Educational and Cultural Exchange Division UNESCO and International Affairs Department Science and International Affairs Bureau Ministry of Education, Science and Culture Government of Japan. *Course of Study for Upper Secondary Schools in Japan* (1983), 1, Ministry of Finance Printing Bureau (Tokyo).

Chapter 5

THE FUTURE OF CDT

The publication of *The National Curriculum 5 – 16* in July 1987, followed the Education Bill which has now completed its passage through Parliament has again thrown the future of CDT into the balance. *The National Curriculum 5-16*[1] clearly identified technology as a subject given a ten per cent allocation of time, possibly to be taught as part of science. Few outside the CDT camp were surprised to see science emerge as the likely senior partner. Nevertheless if schools are to play a key role in reversing Britain's manufacturing decline, they will clearly have to promote innovative skills. The distinctive contribution that CDT offers needs to be recognised and enhanced, not abandoned. This need was further underlined in the document by the separation of design from technology. Initially Design appeared along with art, music and drama, which collectively shared the same time allocation as technology. Craft had apparently disappeared.

Fortunately, however, there followed a bout of intensive lobbying within and without the Department of Education and Science. The outcome has been the establishment of a separate working party in Technology and Design for the National Curriculum at Secondary School level enjoying equal status with the Science working party. The maintainance of a separate existence and the reincorporation of design marked a major victory for the supporters of CDT and high hopes surround the working party chaired by Lady Parkes, a well known enthusiast for the subject. However a price had to be paid – the incorporation of primary school technology into the work of the science working party.

Despite the prospect of CDT in its recently developed form within the national curriculum, there has been remarkably little comment from either inside or outside CDT circles. The author, in an attempt to draw attention to the lack of public debate, wrote to *The Times Educational Supplement* in March 1988, eight months after the publication of the national curriculum. Provocatively captioned by the paper: 'CDT has been suffering a rapid rise to obscurity' the letter resulted in a single reply – and that managed to misinter-

pret the intention behind the original letter![2] How different from the lively correspondence being conducted at the time in the same columns over the Kingman report and the crisis in English teaching. The absence of public discussion is symptomatic of the fact that no one speaks authoritatively on behalf of CDT itself. Compared with the powerful professional associations representing science and mathematics, CDT is sadly divided, its divisions mirroring those of the teaching profession at large. A recent attempt (with some HMI nudging) to rectify the situation has achieved little. The foundation of Destech has so far attracted only a small membership (650 in October 1987) and CDT remains as fragmented as before.

Yet despite divisions in the ranks of CDT teachers they share a common concern with the status of their subject in the curriculum. Until the departments were founded at Loughborough and Brunel Universities, CDT even lacked the academic structure of other curriculum subjects.

CDT is still in an exposed and anomalous position at university level. To use Hirst's categories, it does not come within the "recognized fields or forms of knowlege". Before the days of university departments, Cannon was arguing for design and realization to be considered a form of knowledge, though not for design alone as it did not contain any unique prepositional context. Cannon held that nothing could be found in the design process which did not already exist in logic or mathematics:

> It is only when the design process is seen as a totality, including as essential its world changing realization that it makes an educational case and educational good sense.[2]

An educational justification is sought for practical subjects in the curriculum. Stewart found some of the traditional justifications for the inclusion of craft wanting. He discovered, in craft education literature, that it was believed to develop logical thinking, contribute to the formation of moral values, encourage children to become more self-reliant, persevering and even moral, and to strengthen and vivify other studies. Stewart concluded:

> Unfortunately, they do not stand up well to the analysis of the philosopher or the doubts of the curriculum developer, at least when expressed in such terms. Statements relating to the development of desirable intellectual or emotional qualities are too global to be meaningful, tending to indulge in outmoded faculty psychology. They do not relate specifically to the content of craft subjects.[3]

Down has tried to tease out the philosophical underpinning for CDT to give it the higher status and wider recognition it deserves. Such disputations do not figure prominently in CDT literature. (The Open University came up against this problem of the lack of literature when compiling its book of readings, *Technology in Schools*. A quarter of all the articles came from the one influential academic journal in the field *Studies in Design Education, Craft and*

Technology which, under Eggleston's leadership, has just celebrated its 20th anniversary).

For Down, the practical nature of CDT is the bed-rock on which the subject is founded, hardly a contentious conclusion. However, with the growing gentrification of CDT in its moves towards respectability, even this may be under threat. Down warns of the dangers of intellectualizing practical work out of existence:

> The theory has to go *within* the practical work: within the demonstration and instruction. It is sought as a means of assisting the problem-solving. Obviously the amount of theory and the depth to which it is pursued, will depend upon the capabilities of the children."[4]

He subsequently acknowledged that:

> There might be a place for a more theoretical course in technological analysis, involving studies in applied science and in the solving of theoretical problems related to, say, engineering, but such courses which would compete with subjects like phsyics at A-level, might only have a minority interest[5]

Is this the future direction for CDT? The Secretary of State for Education has stated that he wishes to see both science and technology as part of the core curriculum, and the danger for CDT has gone almost unheeded. The separation of design from technology and the possible disappearance of craft could mean that the route for CDT teaching is about to be blocked off.

CDT at the primary school

If nurturing technological ability is of such importance, why should it be delayed until the secondary stage? Froebel, Pestalozzi and Montessori had all established the educational grounds for practical work as part of the education of all young children. They saw it as a means of developing the senses by a series of manipulative exercises in resistance and plastic materials. Later educationists extended this approach, seeing practical work as a means of bringing colour to other curriculum subjects and as an aid to concept formation in literary, linguistic, scientific and mathematical studies. But craft activity in may British primary schools probably owes more to the influence of the 'Blue Peter' children's television programme. Recycling cast off packaging may stir children to achieve imaginative construction feats, but where is the educational rigour?

The Secretary of State for Education decreed in 1985 that:

> The 5-16 curriculum needs to be constructed and delivered as a continuous and coherent whole, in which the primary phase prepares for the secondary phase, and the latter builds on the former...In the Government's view, older pupils in the primary phase should begin to be systematically intro-

duced to teaching by a member of staff with expertise in an area of the curriculum other that that which the class teacher can offer.[6]

A Design Council working party on design activities in primary education came to a contrary conclusion, asserting that primary schools should not be viewed...

As simply providing a grounding for secondary education. Primary education must also enable children to confront their own world successfully. We echo very firmly the words of the Cockcroft Committee, in its report on the teaching of mathematics in schools: "The primary years ought also to be seen as worthwhile in themselves – a time during which doors are opened on to a wide range of experience."[7]

Who is correct? Just as primary school teachers can find a literature on reading readiness and the development of number concepts, they can study Herbert Read to understand the stages children progress through in art education.[8] The Nuffield research team in its excellent 'Science 5/13' project, structured its learning material according to current research relevant to the teaching of technology.[9] They identified specific learning stages, but were clear about the way that teachers should approach them:

The stages conveniently describe for us the mental development of children between the ages of five and thirteen years, but must be remembered that although children go through these stages in the same order they do not go through them at the same rates. Some children acheive the later stages at an early age. Some loiter in the early stages for quite a time. Some never have the mental ability to develop to the later stages.

All appear to be ragged in their movement from one stage to another...in any one class of children there will be almost certainly, some children at differing stages of mental development.[10]

It seems unlikely that such an approach can inform the introduction of CDT teaching material. Nor is enough thought given to what blend of CDT should be encouraged in primary schools. Primary CDT is suffering from the same mixture of political pressures and opportunism that may override educational considerations in the secondary sector. The Design Council working party explored how design-related activities could best be fostered. It singled out the areas of art, craft and technology as specially significant but it was central to their argument that "design-activities are found throughout the activity of the primary school".

HM Inspectorate endorsed the importance of the aesthetic and the creative so that children might respond "emotionally and intellectually to sensory experience," and develop an "appreciation of beauty and fitness for purpose."[11] The Inspectorate agrees with the Design Council's Working Party that, whilst aesthetic and creative experience may occur in any part of the curriculum...

Art, craft, design, some aspects of technology, music, dance, drama and the theatre arts, in particular, promote the development of the imagination and the creative use of media and materials.

The Inspectorate were breaking new ground by specifically including technology in the primary curriculum: Young children can be taught to understand that, while steel is hard, it is also elastic; that glass is not only brittle but strong; that some materials deform irrevocably when stretched while others regain their former shape; that some materials change their characteristics is important when it comes to choosing materials for the solution of particular problems. In addition they need to be aware of aesthetic qualities such as texture, colour and form...Equally important is the concept of energy with which all technologies are concerned. Pupils in primary schools should acquire an intuitive feel and some empirical knowledge about ways in which energy can be stored, transformed and, above all, applied to control.[12]

These are in essence the same objectives as the Nuffield researchers were promulgating in the early seventies. Why has so little been achieved? The slow take-up of ideas is, as at secondary level, due to the lack of interested, experienced and suitably qualified teachers. At primary level, specialists training relies heavily on in-service programmes for ordinary classroom teachers and, to a lesser extent, on the appointment of specialist subject teachers. The Design Council report expressed the hope that professional courses for teachers would enable them...

to acquire sufficient practical and organisational competence to handle design-related activities including those stemming from art, craft, science and technology in the primary classroom. Pressures to increase subject specialism should not inhibit this.

A straw poll of some forty primary school teachers in 1987 revealed a degree of hesitancy about their ability to handle design activities – even amongst those who attended in-service training courses. Evans, who pioneered the introduction of technology in his rural Devon Primary school, offers some encouragement.

My own formal qualifications in science and technology barely exceeded that of the average Welsh rural dean who thinks of magnetism, exclusively, as an oratorial quality, and it is not so long ago that I believed Pawl and Ratchet to be characters from Dickens.[13]

Evans soon found himself giving lectures to promote primary school technology and the National Centre for School Technology published a book based on his experience. But one cannot expect all primary school teachers to respond as effectively. Over the years the education system has benefitted enormously from teachers whose enthusiasms and eccentricities have enriched

the traditional curriculum but they could well be constrained by the imposition of a national curriculum.

One of the most ambitious attempts to kindle a love of technology in young children is being made in the private sector. Warlingham Park School in Surrey, founded by Sexton who was an adviser to the former Secretary of State for Education, has a curriculum with a technological bias,[14] but at the end of the first school year in 1987 there were still only 21 pupils on roll. The educational case for the introduction of technology into primary schools is strong. It is not unlike Dewey's argument for craft in his experimental school. Nevertheless, the sudden interest in primary school technology owes more to wanting to strengthen the supply of skilled labour then to educational theory. As related in chapter 1, Garnett attempted to combine the two in 1884. His hope that mechanical toys would enable "our children to become mechanical engineers without knowing it", ushered in the meccano age. Are the appropriate foundations now being laid for the twenty-first century?

Foundations for the future
CDT had enjoyed some conspicuous local successes and frequently received the attention of policy makers in government and industry. One of many significant recent initiatives has been by the Independent Schools Joint Council, which has set up the Centre for Design and Technology at Westminster College, Oxford, with impressive industrial funding. When one remembers the huge impact when the same schools set up their industrially funded science initiative in the early sixties, the possibilities are likely to be wide ranging. Elsewhere initiatives such as the Young Electronic Designer of the Year Competition, sponsored by Texas Instruments and Cirkit, are playing a major role in bringing the work of CDT Departments to public attention and recognition./ But perhaps the most significant factor in the future of CDT is the role of Her Majesty's Inspectorate. To suggest that the Inspectorate should lose its distinctive role within the subject and be replaced by leaders drawn from the universities sounds suspiciously like an ill-disguided case of self-pleading. However, as many in the Inspectorate would agree, it is impossible today for the Inspectorate to assume the role of subject leaders in the sense of being the experts in subject knowledge. Inspectors nowadays derive their authority principally from interpretation, implementation and administration. The legendary workload of HM Inspectorate, now increasingly experienced by LEA advisers too, precludes their doing more than keeping abreast of subject knowlege. The contribution of HM Inspectorate to CDT teaching has always gone far beyond the bounds of their bureaucratic framework. There has been a manifestly emotional (not a word in the Civil Service vocabulary) concern with the subject. Ever since Board of Education days, the publication of HMI reports have influenced practical work in the curriculum. What other subjects can claim to have the loyal and active support of the like of Porter and Swain (former Staff Inspectors) years after their retirement? Their distilled wisdom has helped the passage of the subject through some testing years. The recent

series of HMI publications on CDT which match the new subject areas of the GCSE examinations are an impressive example of the continuing role of the Inspectorate to fostering and facilitating development. A recent publication, *Design and Communication* (HMSO 1987)[15] exemplified the high quality of the Inspectorate approach.

Bath University is soon to join Loughborough, Brunel and Goldsmiths College, London in initial training and, on the in-service front, Warwick. But this will not necessarily secure the future of CDT. Neither Loughborough nor Brunel have escaped criticism from detractors, from both within and without. Both departments faced immense difficulties in bridging the gap between College of Education and university status during the most trying of transition circumstances. The unconvinced will argue that the subject has made its most rapid headway largely without their help in polytechnics such as Leeds, Trent, Middlesex, Wolverhampton, Sunderland, Thames and many others so why should they be so necessary in the future? They view the problem only in terms of practicalities, believing that pernickety issues like wider 'A' level acceptance will disappear when DES heavies lean on the universities to see sense. There prevails the simplistic belief that everything can be sorted out by more intensive in-service training, especially as GRIST and TRIST initiatives lead towards more local autonomy and away from centralised policies.

To believe this is to misunderstand what is at stake. University departments do not exist solely to provide what might be seen as upmarket teacher education courses; they also have a research function. The universities, with greater technological resources than individual college departments, have lifted school technology to a different plane. Rawson at Brunel, Britton at Loughborough, Eggleston at Warwick and Harrison at Trent Polytechnic have greatly strengthened its standing in the schools. School technology now has exponents of standing who can preach and practise as did the Barnsleys, Goughs, Cannons and Fowles of yesteryear. To be taught technology by academics involved in research, as is the norm in other subjects, is enriching for potential teachers of technology. There are, however, few comparable appointments in design, and craft does not fit easily into the university framework. Acquiring specialist knowledge in technology is a relatively straightforward business in which the universities excel. How this is best transmitted and taught in an educational context is another matter. CDT is conspicuously the most under-researched area of the curriculum. Qualitively and quantitively, the surface has only just been scratched, but it is essential if CDT is to have any long-term credibility. Unfortunately there are few indications of research taking off; some of the most precious of CDT tenets are still based on hearsay, folk-lore and hunches; the literature is virtually non-existent.

The Assessment of Performance Unit

Moves which originated with the two major Schools Council projects in the sixties have latterly been helped on their way by the Assessment of Performance Unit. The APU Report, *Understanding Design and Technology* published

in 1982, set the parameters for subject development and helped provide the framework for GCSE. It argued the case for design and technology to be equated intellectually with traditional subjects but recognised how it differed from them in important respects, especially in the extent it crossed subject barriers. The report nevertheless attempted to identify the unique features of design and technology.

> The dominant feature of activity in the area of design and technology is the bringing together of skills, experience, knowledge, understanding, imagination and judgement, whatever their limitations, in the execution of a specific task. In practice, it involves the integration of a complex of activities which are specific − because they relate to a particular need; inventive − because they call for a creative response; effective − because the end result should reflect a better fit or match between need and provision than existed formerly; and evaluative because the designer is called upon, throughout the process, to exercise value judgements of many kinds when ariving at the proposed solution. Evaluating the efficacy of the final solution against the original need is perhaps the most demanding task of all.[16]

The disparate nature of design and technology posed difficulties of assessment for the Unit, but after several years of patient negotiation a major project is underway based at Goldsmiths College London. The first major publication of the project team *Design and Technological Activity* [17] has recently been published; it has been widely praised as offering a basis for assessing both the intellectual and practical aspects of performance in design and technology. Interestingly the project is recognised as the most complex and difficult yet undertaken by the APU. Yet its progress to date suggests that it may provide the breakthrough in identifying the all round contribution of Design and Technology in a way that will provide the basis for answers to many of the problems that have been reviewed in this volume.

The approach of the project team indicates a sharp awareness of the magnitude of the task; it is illuminating to quote the first page of their report:

> Describing design and technology is not a straightforward matter. Previous APU surveys (eg in mathematics or science) have been able to appeal to a well established tradition of understanding and curriculum practice in order to describe what they are concerned to measure. Because of the cross curricular nature of design and technological activity, and its relatively recent appearance in schools' curricular there is less clarity and consensus about traditions and practices.

> There are a number of curriculum subjects, notably craft design and technology (CDT) and technology that in recent years have developed coherent but somewhat different approaches to the development of understanding and capability. These courses have been widely recognised as motivating, demanding and desirable features in the education of all

pupils. There have been similar developments in home economics and textiles, and in some art and design courses. From the basis of existing practice, however, it is difficult to achieve an acceptable and all embracing definition first of design – and second of technology – and hence of 'design and technology'. An appeal to existing examination titles and syllabuses as a source of clarification is also largely unhelpful, as collectively they reflect the confusions that exist. The task of describing the activity must, therefore, involve unravelling the concept of design and technology and identifying the contributing elements.

There is some confusion between industrial and educational perspectives on the activity. In education the concern is to expose pupils to design and technological experiences in order that they may develop understanding and capability. In industry that design and technological capability is directed towards the manufacture of a product or system. Whilst the product is of less importance than the process to education we must recognise the interdependence of these two perspectives on the activity.

There is a developing awareness of the common purposes and practices that unite not only much of the work of subjects in the design and technology area of the curriculum, but also other related areas such as science, mathematics, and the humanities. Within this APU project therefore, the first task for the research team has been to derive a coherent and acceptable description of the activity of design and technology, noting the features of performance which, because they are central to development of capability through the activity, will be used in monitoring. This publication summarises these deliberations, and outlines an approach to monitoring.

More fundamentally the work of the APU may yet create the opportunity to revive the idea that CDT could be part of the liberal education of all children. John Dewey demonstrated the value of practical problem-solving activities as a marvellous vehicle for education. Teachers following in his footsteps have shown that practical subjects, properly taught, have enormous potential to motivate youngsters and enrich a wide spectrum of learning. A CDT research programme which took Dewey's experiments as a starting point could produce intriguing results. But even so, without teachers with fire in their bellies it can be no more than the stuff that dreams are made of – as no more than the dreams of nineteenth century pioneers such as John Moss:

> The school workshop...should be an integral part of the education system adapted to the requirements of industrial communities. It should be a means of illustrating scientific principles and of applying in practice theories which of themselves, too often appear to the pupils as useless dry bones.

(John Moss, Clerk to the Sheffield School Board 1884).

References
1. DES *The National Curriculum 5-16*, 1987), HMSO.
2. A. Cannon 'Design and Realization as a Form of Knowledge' *Studies in Design Education and Craft* 8.1, p.40.
3. R. Stewart 'Justifying Craft in the Curriculum' *Studies in Design Education and Craft* 6, p.73.
4. B.K. Down 'Craft as a Liberal Education?: A Response.' *Studies in Design Education and Craft* 9.2, p.290.
5. B.K. Down *'Educational Aims in the Technological Society' Studies in Design Education Craft and Technology* 16.2, p.74.
6. DES *Better Schools* HMSO (1985), 21.
7. Design Council *Design and Primary Education* (1987).
8. H. Read *Education through Art* (1968).
9. Schools Council *Science from toys* (1972)
 Schools Council *Metals* (1973)
 Schools Council *Metal background* (1973)
 Schools Council *Working with wood* (1972)
 Schools Council *Working with wood background* (1972)
10. Schools Council *Working with wood* (1972), 79.
11. DES *The Curriculum from 5 to 16* (1985), HMSO.
12. *Ibid.*, 35.
13. National Council for Schools Technology, P. Evans *A Course of Primary School Technology,* (1983).
14. *The Sunday Times* (19 July 1987).
15. Department of Education and Science. *Design and Communication* (1987), HMSO.
16. Department of education and Science, Assessment of Performance Unit *Understanding Design and Technology* (1982).
17. Department of Education and Science Assessment of Performance Unit, *Design and Technological Activity,* (1988) HMSO.

INDEX

STUDIES IN DESIGN EDUCATION CRAFT AND TECHNOLOGY:
A JOURNAL OF NEW APPROACHES
Edited by John Eggleston

This journal is designed to focus attention on developments in the whole field of design and craft education ranging from art through the crafts to applied science and technology. It pays attention to case studies of new approaches in schools and colleges written teachers and tutors undertaking them. A selection of the growing number of important researches and studies in design education is an important feature of the journal as is the review of all important new literature.

In the twenty years since publication began, *Studies in Design Education Craft and Technology* has become established as the leading independent journal in its field and is read in almost every country in the world. It is essential reading for all specialists in this important field.

FIRST PUBLISHED AUTUMN 1967
ISSN 0305 766
Price: £13.00 (Overseas £16.00)
(Three issues: Autumn, Spring and Summmer)
BACK ISSUES: £5.00 each.

TRENTHAM BOOKS
151 Etruria Road, Hanley, Stoke-on-Trent ST1 5NS